# HUMAN ANATOMY MADE AMAZINGLY EASY

# HUMAN ANATOMY MADE AMAZINGLY EASY

BY CHRISTOPHER HART

WATSON-GUPTILL PUBLICATIONS/NEW YORK

*For Maria*

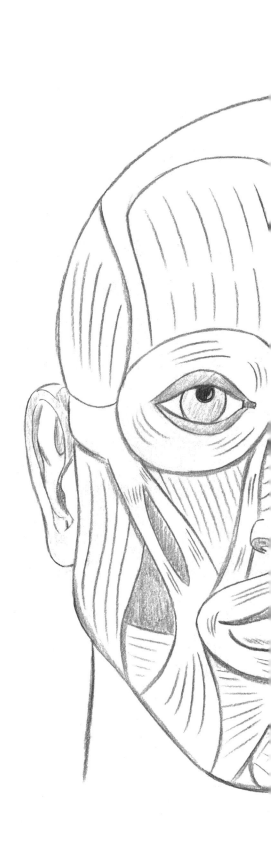

Cover design by Bob Fillie, Graphiti Design, Inc.

Senior Editor: Candace Raney
Editor: Jacqueline Ching
Designer: Bob Fillie, Graphiti Design, Inc.
Production Manager: Ellen Greene

The text of this book is set in 11 pt. Bodoni Book.

Published in 2000 by Watson-Guptill Publications,
a division of VNU Business Media, Inc.,
770 Broadway, New York, NY 10003

Visit us at http://www.watsonguptill.com

**Library of Congress Cataloging-in-Publication Data**
Hart, Christopher.
   Human anatomy made amazingly easy/Christopher Hart.
       p.   cm.
   ISBN 0-8230-2497-0
   1. Anatomy, Artistic. 2. Human figure in art. 3. Drawing—Technique.
   NC760.H29   2000
   743.4'9-dc21
                       00-043514
                       CIP

ISBN 0-8230-2497-0

Printed in the United States of America.

First printing, 2000

7 8 9/08 07 06 05 04 03

# CONTENTS

**INTRODUCTION 7**

**THE HUMAN HEAD 8**
Drawing the Profile
The Contours of the Face
The Human Skull
Bones that Show Through on the Face
The Human Skull: Profile
Bones that Show Through on the Face: Profile
The Muscles of the Face
The Planes of the Face
The Hills of the Face
The Valleys of the Face
The Shadows of the Face
Hints for Drawing the Head
Head Rotations
Foreshortening and the Head

**THE FEATURES OF THE FACE 24**
The Eye and Eyebrow
Drawing the Eye in Perspective
Types of Eyebrows
The Nose
Deconstructing the Nose
The Nose from Various Angles
Examples of Other Noses
The Lips
Smiles, and the Shape of the Lips
Men's Lips
Lip Expressions
The Ear
More Angles of the Ear
Putting It All Together
The Angled Head
Creating Unique Characters
Caricature and Anatomy

**THE SKELETAL STRUCTURE 46**
The Bones of the Limbs
The Skeleton: Proportions
The Simplified Skeleton: Self-Checking Proportions
The Skeleton: Back View
The Simplified Skeleton: Side View
Comparative Anatomy: Male and Female Pelvis
Bones that Show Through the Body: Front View
Bones that Show Through the Body: Back View
The Simplified Figure
Planes of the Body

**THE FEATURES OF THE BODY 58**
The Major Muscles
Knowing Your Muscles
Shadows Created by the Muscles
The Muscles of the Neck

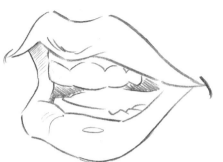

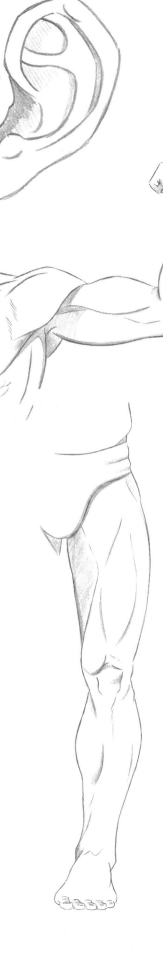

Muscles of the Arm
"The Show-Through" Bones of the Arm
The Forearm
Under the Arm
The Shoulder
The Shoulder Blade (Scapula)
The Moveable Shoulder Blades (Scapulae)
The Back, without Muscles
The Major Muscles of the Back
Filling Out the Muscles of the Back
Surface Muscles of the Back: The Athlete
Surface Anatomy of the Back: The Average Person
The Chest and Rib Cage
Thin Subjects
The Major Muscles of the Leg: Front View
The Major Muscles of the Leg: Side View
The Major Muscles of the Leg: Back View
Lines of Compression
The Knee
Drawing the Knee, Variations
The Hand
The Back of the Hand
More Hints for Hands
Female Hands
The Feet

**THE DYNAMICS OF THE BODY  94**
Asymmetry
Asymmetry of the Upper Arm
Asymmetry of the Triceps
Asymmetry of the Forearm
Asymmetry of the Knee and Calf
Asymmetry of the Ankle Bones
Muscles: Stretching and Flexing
Diminution
Foreshortening
Foreshortening and Elimination
Shifting Weight and Balance
Why Does the Hip Sag?
The Weight-Bearing Leg
Measuring Points for Weight-Bearing Poses
The Misleading Knee
Drawing from a Model: The Use of Measuring Points
Negative Space
Walking
Flowing Poses and the Line of Action
Finding Multiple Lines of Action
Using Two Lines of Action in the Same Pose
Half Lines of Action
The Point of Balance
Perspective of the Body
The Effects of Perspective on the Body

**PRACTICE POSES  134**
Seated Pose: Front View
Standing Pose: Back View
Reclining Pose: Front View
Reclining Pose: Side View
Reclining Pose: Back View

**INDEX  144**

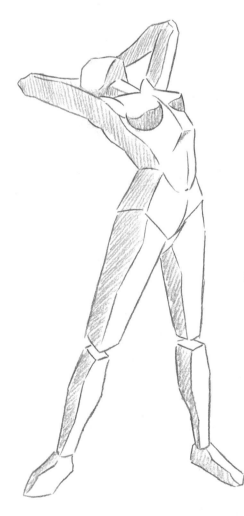

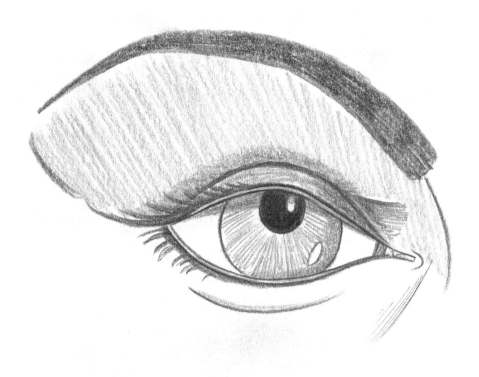

What is it with anatomy books? Why are they so difficult to follow, so complex, technical, and dry? The art student, whether his or her interest is in fine art or commercial art, requires information about proportions, musculature, and skeletal structure to empower him or her to draw the figure with authority, confidence, and ease.

But the average anatomy book, by and large, looks like a coroner's diagram. Every muscle and bone is examined, not only the muscles that can be seen, but all of the secondary and tertiary muscles that exist under layers of other muscles —muscles so deeply buried underneath the surface muscles that they bear little impact, if any, on how the figure looks.

By focusing the same attention on the "show" muscles as they do on the visually insignificant muscles, authors of anatomy books unduly complicate a rather straightforward subject. There are 520 muscles in the human body. It defies common sense to treat each of them equally. There are many tiny bones in the human ear. But so what? It adds nothing to the understanding of artistic anatomy to be able to memorize those bones.

This book focuses on the areas important to art students, and on those areas, it is extremely thorough. Within this book, you will find clearly illustrated information on how to draw the eyes, nose, ears, hands, feet, as well as the larger areas of the body, such as arm muscles, leg muscles, abdomen, chest, and pelvis. You'll learn how the contours of the face and body create pools of shadows. You'll also learn how to incorporate the use of perspective on the body, the secrets of foreshortening and diminution, and much more.

While most anatomy books focus on drawing individual muscle groups, rarely do they tie them all together by demonstrating how to achieve a graceful, flowing look to your drawings. In this book, you will learn the secrets to drawing action poses, seated poses, walking poses, reclining and gesture poses. You'll learn a shorthand method for drawing the figure that begins with easy shapes, rather than a complicated series of steps.

No one has access to a model at all times. As an artist, you must be able to draw life from your imagination. In this regard, anatomy alone won't help you. You need a reliable method of self-checking the proportions of the head and figure so that you can tell when your drawings are off, and make the necessary adjustments to correct it. These self-checking methods will be clearly illustrated and easy to follow.

It has been said that life drawing is the foundation of all art. It is my belief that this foundation should be fun, easy, but most of all, useful.

# THE HUMAN HEAD

As with any endeavor, drawing the head is only difficult if you don't know the steps. By drawing the head in stages, you will see that what appears complicated is, in reality, only a logical progression. Up until now, you have probably been more concerned with the aesthetics, or the expression of the human head. We're going to focus, instead, on the spatial relationships among the features of the face. Let's begin:

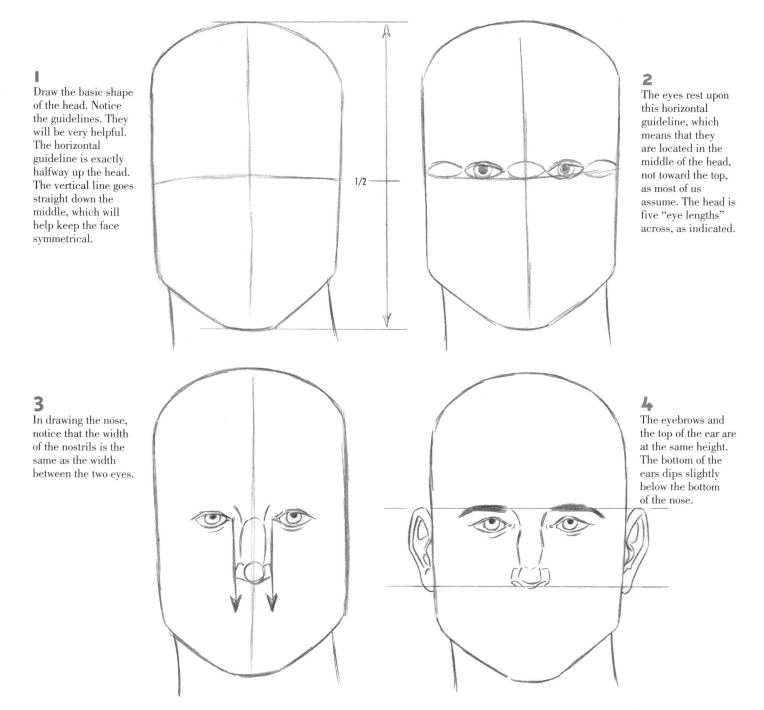

**1**
Draw the basic shape of the head. Notice the guidelines. They will be very helpful. The horizontal guideline is exactly halfway up the head. The vertical line goes straight down the middle, which will help keep the face symmetrical.

1/2

**2**
The eyes rest upon this horizontal guideline, which means that they are located in the middle of the head, not toward the top, as most of us assume. The head is five "eye lengths" across, as indicated.

**3**
In drawing the nose, notice that the width of the nostrils is the same as the width between the two eyes.

**4**
The eyebrows and the top of the ear are at the same height. The bottom of the ears dips slightly below the bottom of the nose.

**5**
The bottom of the lips is on the same level as the angle of the jaw.

**6**
Notice that the protrusion of the cheekbones peaks at about the middle of the ears, and the contour of the cheekbones travels down to the edges of the lips.

**7**
Add thickness to the side of the head, and draw a layer of hair. Notice the contour of bone around the eyes, as indicated by the small arrows.

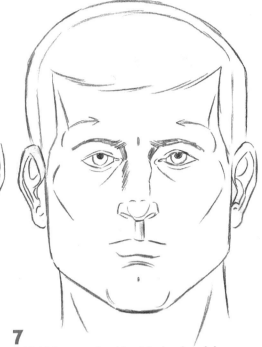

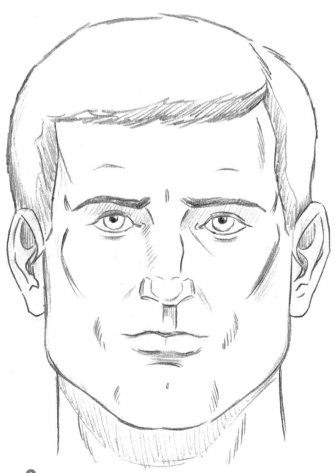

**8**
Now add details, such as the indications of the muscles of the face, which is explained more fully later in the chapter.

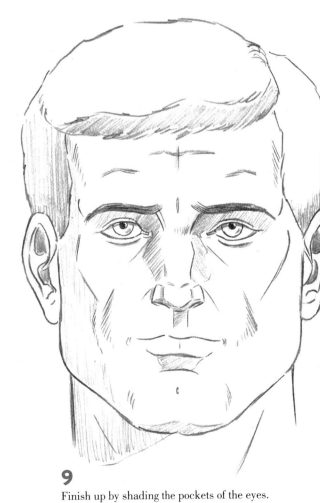

**9**
Finish up by shading the pockets of the eyes.

# DRAWING THE PROFILE

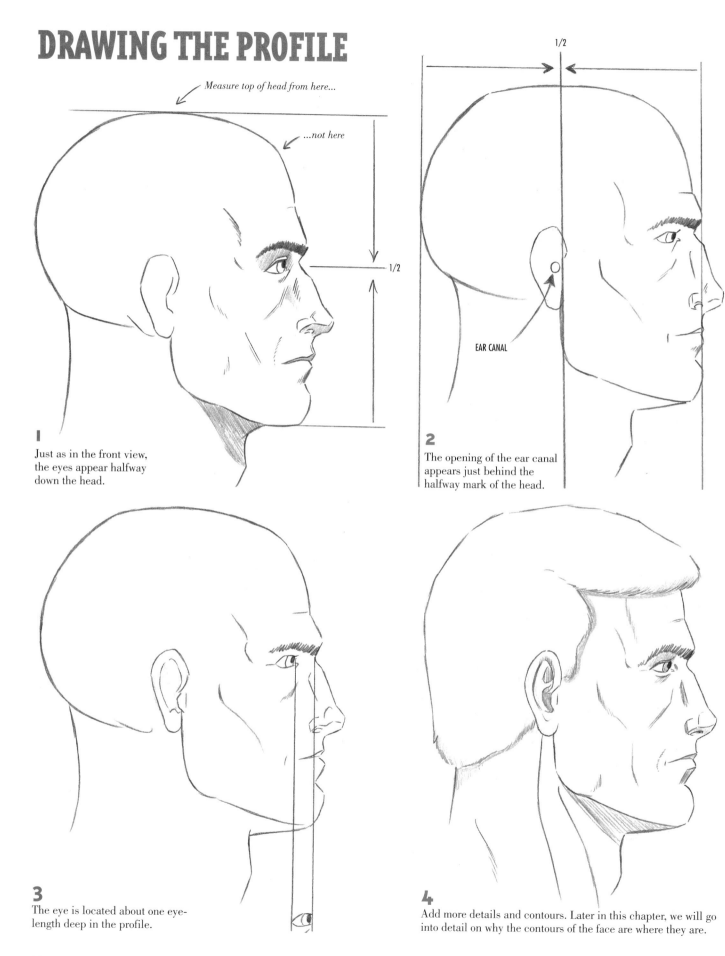

*Measure top of head from here...*

*...not here*

1/2

**1**

Just as in the front view, the eyes appear halfway down the head.

1/2

EAR CANAL

**2**

The opening of the ear canal appears just behind the halfway mark of the head.

**3**

The eye is located about one eye-length deep in the profile.

**4**

Add more details and contours. Later in this chapter, we will go into detail on why the contours of the face are where they are.

# THE CONTOURS OF THE FACE

These are the general patterns that are made by the bones and muscles of the face. Of course, they can be subtle or pronounced, depending upon the amount of fat the person has.

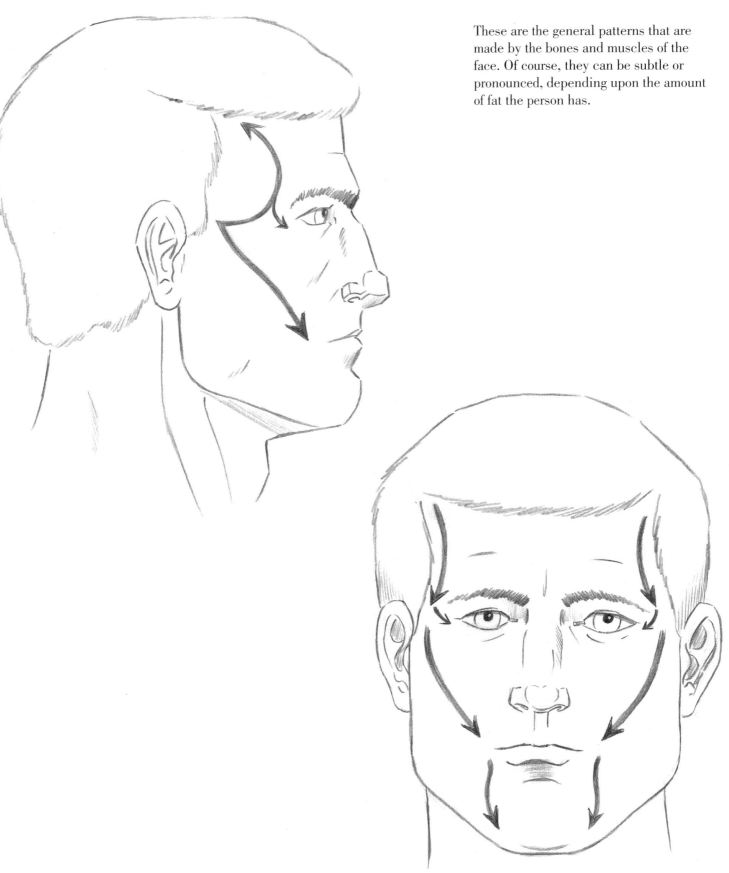

# THE HUMAN SKULL

The skull is the architectural blueprint of the head. It dictates the overall shape of the face. The head is made up of two major masses, the cranium, which goes from the top of the skull to the upper teeth, and the mandible, which includes the jaw and the bottom teeth—the moveable part of the skull. The eyes sink inside the face because the eye sockets are, quite literally, holes in the head. Our cheeks tend to sink in, because of the empty pockets of space surrounding the jaw. The cheekbone, or zygomatic bone, and the chin bone, or mental protuberance, are always prominent.

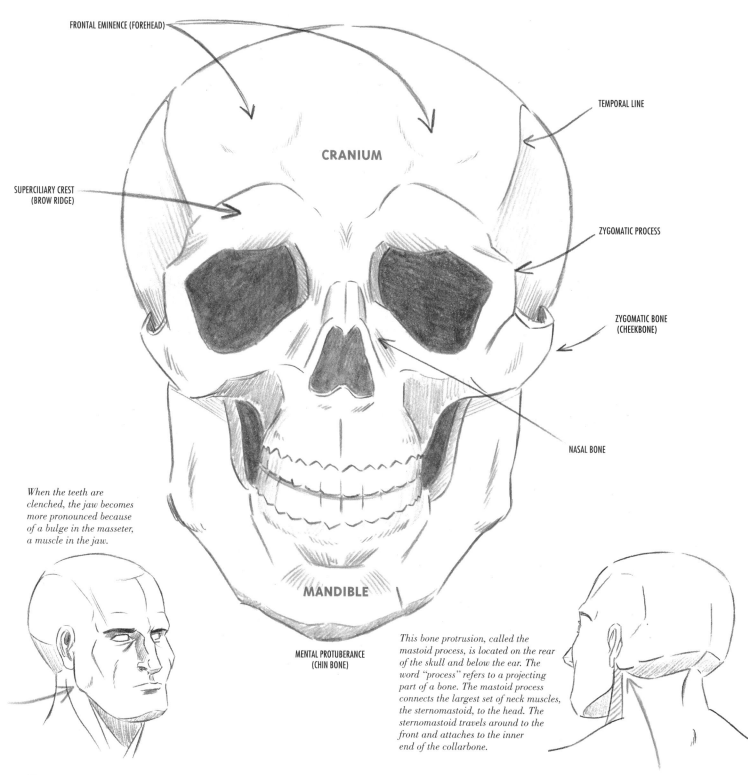

FRONTAL EMINENCE (FOREHEAD)

TEMPORAL LINE

CRANIUM

SUPERCILIARY CREST
(BROW RIDGE)

ZYGOMATIC PROCESS

ZYGOMATIC BONE
(CHEEKBONE)

NASAL BONE

*When the teeth are clenched, the jaw becomes more pronounced because of a bulge in the masseter, a muscle in the jaw.*

MANDIBLE

MENTAL PROTUBERANCE
(CHIN BONE)

*This bone protrusion, called the mastoid process, is located on the rear of the skull and below the ear. The word "process" refers to a projecting part of a bone. The mastoid process connects the largest set of neck muscles, the sternomastoid, to the head. The sternomastoid travels around to the front and attaches to the inner end of the collarbone.*

# BONES THAT SHOW THROUGH ON THE FACE

Now you can see the reason why it is necessary to have a working familiarity of the skull. Many of the bones of the skull partially show through when you look at the human face. The skull affects the shape and shading of the contours of the face. But do not slavishly copy every bone when drawing the face. A small indication here and there is sufficient. In heavyset characters, very few bones will show through.

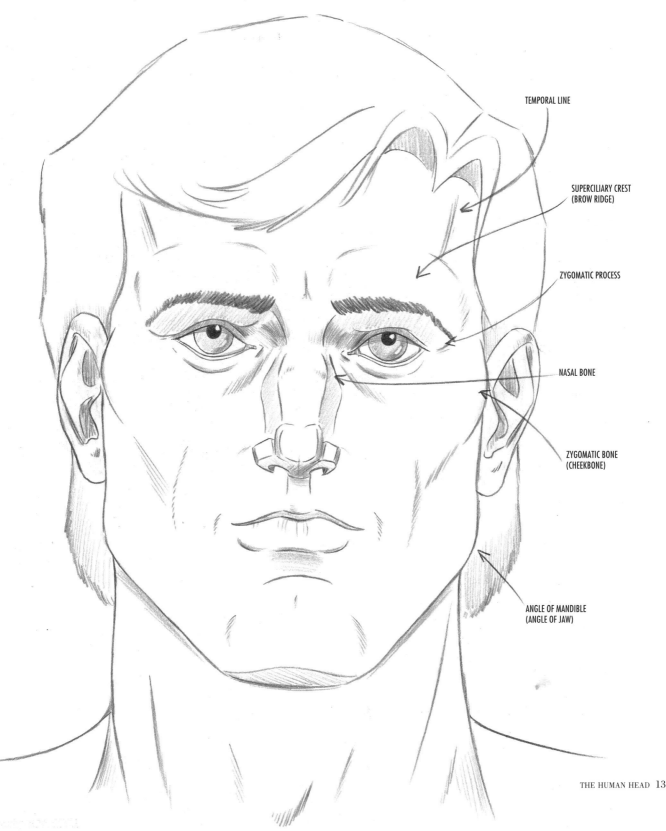

TEMPORAL LINE

SUPERCILIARY CREST
(BROW RIDGE)

ZYGOMATIC PROCESS

NASAL BONE

ZYGOMATIC BONE
(CHEEKBONE)

ANGLE OF MANDIBLE
(ANGLE OF JAW)

# THE HUMAN SKULL: Profile

Notice that the nose is mostly made up of cartilage and is not part of the structure of the skeleton. This contributes to the difficulty some people have in drawing the nose. They believe that the nose is either all bone or completely malleable, when it is in fact a combination of the two. In order to draw the nose accurately, it is important to know where the bone ends and the cartilage begins. We will cover the nose in depth in the next chapter.

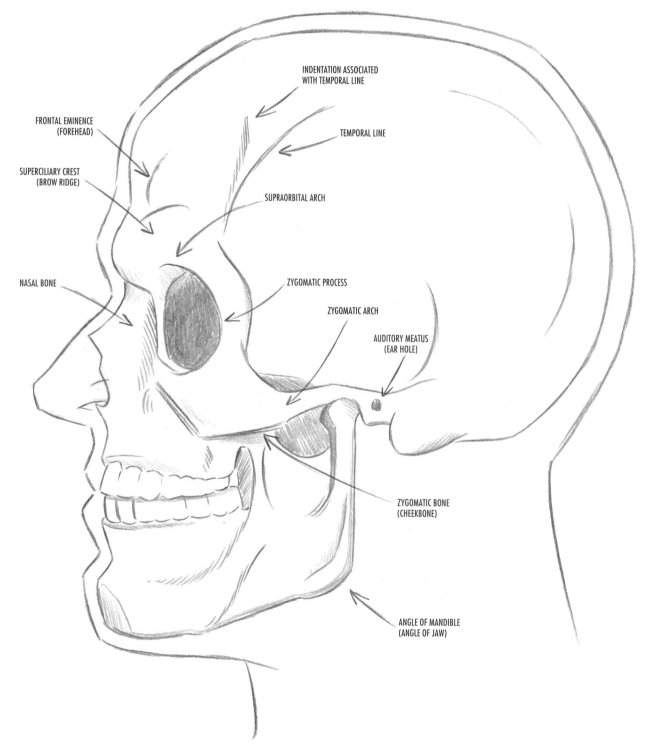

INDENTATION ASSOCIATED
WITH TEMPORAL LINE

FRONTAL EMINENCE
(FOREHEAD)

TEMPORAL LINE

SUPERCILIARY CREST
(BROW RIDGE)

SUPRAORBITAL ARCH

NASAL BONE

ZYGOMATIC PROCESS

ZYGOMATIC ARCH

AUDITORY MEATUS
(EAR HOLE)

ZYGOMATIC BONE
(CHEEKBONE)

ANGLE OF MANDIBLE
(ANGLE OF JAW)

# BONES THAT SHOW THROUGH ON THE FACE: Profile

Keep a light touch, but show some bones. By doing so, you give your drawing a feeling of authority and anchor it in reality. It has all of the landmarks of a real face, and people will subconsciously respond to its authenticity.

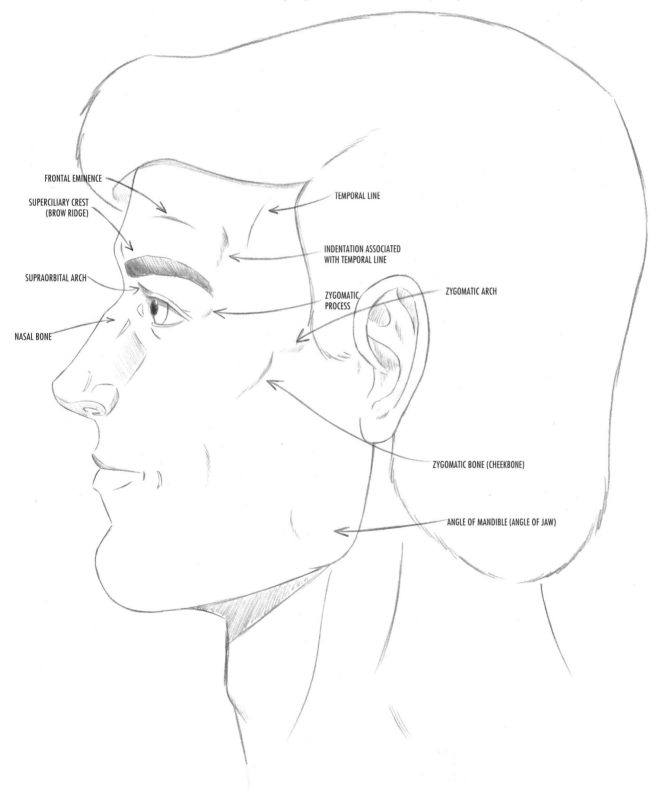

FRONTAL EMINENCE

SUPERCILIARY CREST
(BROW RIDGE)

SUPRAORBITAL ARCH

NASAL BONE

TEMPORAL LINE

INDENTATION ASSOCIATED
WITH TEMPORAL LINE

ZYGOMATIC
PROCESS

ZYGOMATIC ARCH

ZYGOMATIC BONE (CHEEKBONE)

ANGLE OF MANDIBLE (ANGLE OF JAW)

# THE MUSCLES OF THE FACE

It's surprising to see just how many different muscles are at play in the face. We usually think of the face as bone and skin, but it is the facial muscles that enable us to raise an eyebrow, crinkle a nose, bite our lip, yawn, and make any expression. All movement is possible because of muscles alone. Without them, we are reduced to an inanimate skeleton and a circulatory system.

There is no need to commit all of these muscles to memory. Just observe. Notice the circular muscles that orbit the eyes, and the oval muscles that frame the lips. Also notice where there are no muscles—the pockets that allow our cheeks to sink inward.

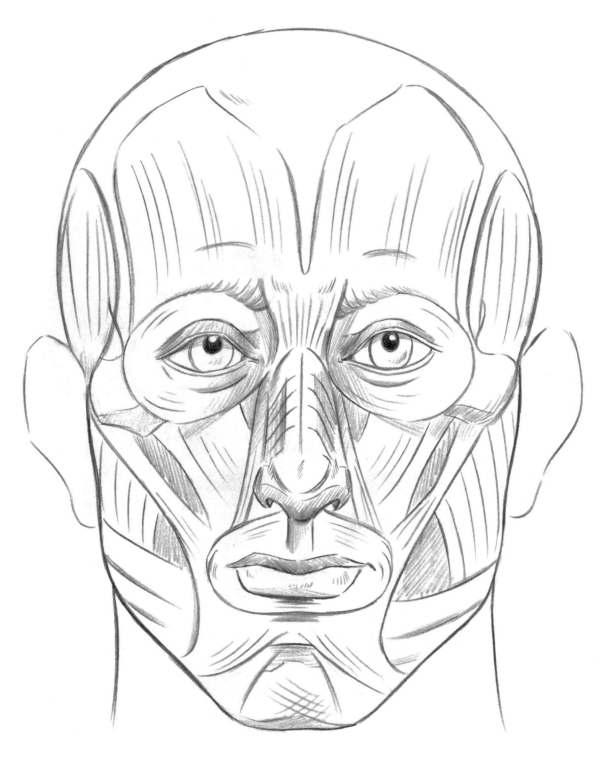

# THE PLANES OF THE FACE

The face is not a smooth surface. It is formed by "hills and valleys." The light, which is usually overhead in the form of incandescent light or sunlight, hits the hills and casts shadows on the valleys. Each hill and valley create new planes of the face.

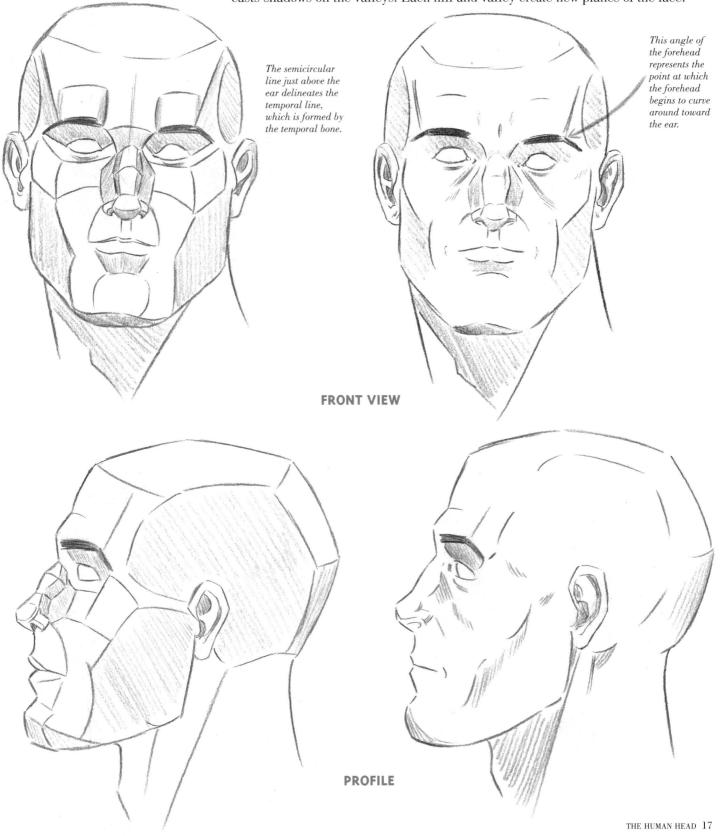

*The semicircular line just above the ear delineates the temporal line, which is formed by the temporal bone.*

*This angle of the forehead represents the point at which the forehead begins to curve around toward the ear.*

**FRONT VIEW**

**PROFILE**

# THE HILLS OF THE FACE

Usually, the planes of the face are subtler, unless the lighting is unduly harsh or the drawing is supposed to be dramatic. By making subtle use of the planes, you can draw the face more convincingly, moving almost imperceptibly from one plane of the face to the next. What follows are the topographic high points of the face.

LOWER FOREHEAD JUST ABOVE THE EYES

CHEEKBONES, JUST BELOW THE EYES

BRIDGE OF NOSE

AREA JUST ABOVE UPPER LIP

ANGLE OF JAW

CHIN

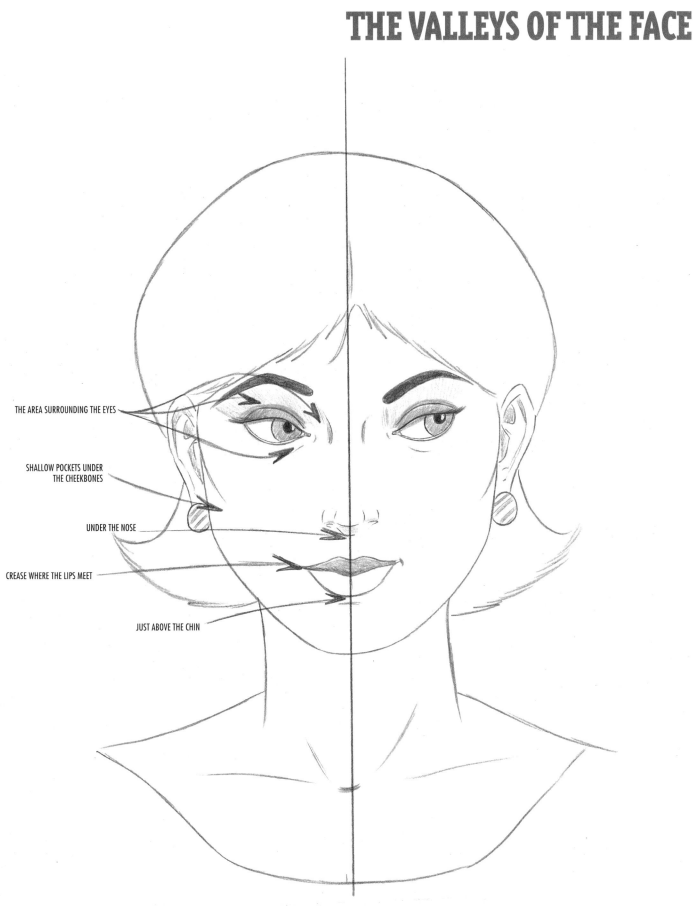

THE AREA SURROUNDING THE EYES

SHALLOW POCKETS UNDER
THE CHEEKBONES

UNDER THE NOSE

CREASE WHERE THE LIPS MEET

JUST ABOVE THE CHIN

# THE SHADOWS OF THE FACE

It is difficult, if not impossible, to add shadows to the face without an awareness of the planes of the face, because shadows bring them out. The shadows of the face occur not only in the valleys, as we have already noted, but also in deeper facial creases. Shadows also tend to pool together. For example, notice the line of the cheekbone and how it merges, by way of shadows, with the line of a smile crease, which also merges with the line of the chin, to form one long shadow along the side of the face. There is almost always a shadow on the neck, just under the jaw, unless the face is being lit from underneath.

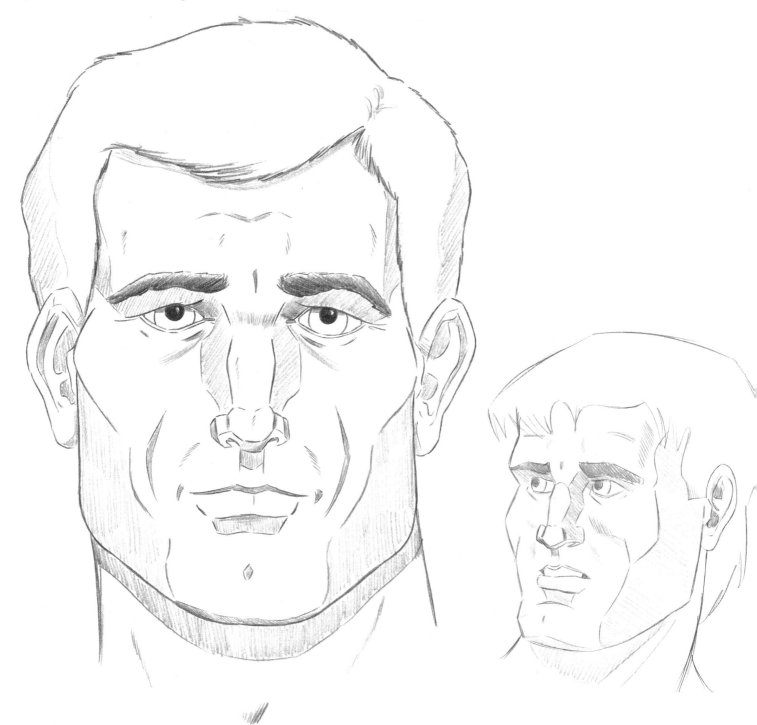

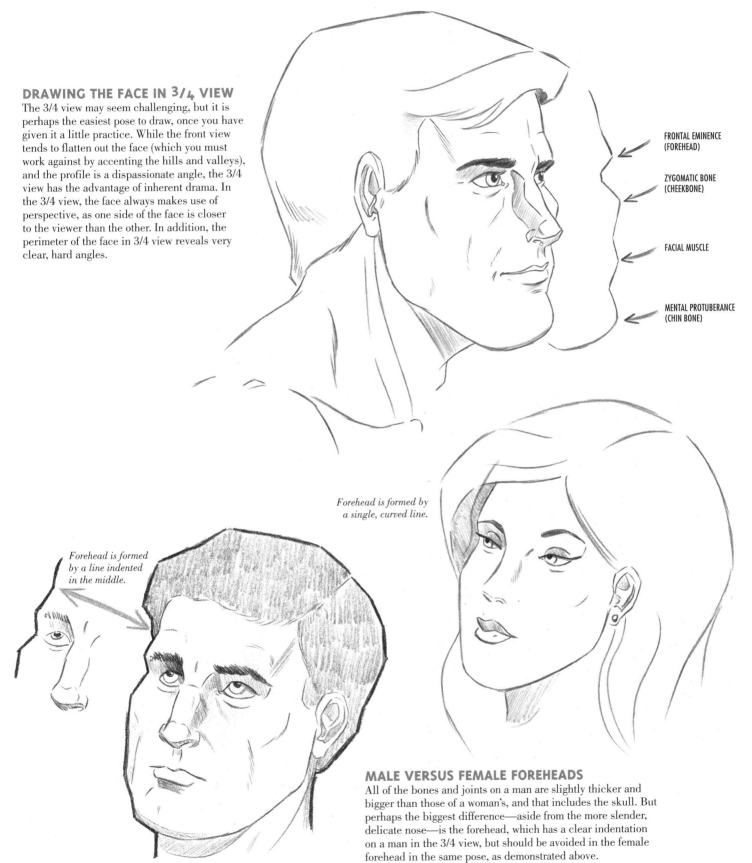

## DRAWING THE FACE IN 3/4 VIEW

The 3/4 view may seem challenging, but it is perhaps the easiest pose to draw, once you have given it a little practice. While the front view tends to flatten out the face (which you must work against by accenting the hills and valleys), and the profile is a dispassionate angle, the 3/4 view has the advantage of inherent drama. In the 3/4 view, the face always makes use of perspective, as one side of the face is closer to the viewer than the other. In addition, the perimeter of the face in 3/4 view reveals very clear, hard angles.

FRONTAL EMINENCE
(FOREHEAD)

ZYGOMATIC BONE
(CHEEKBONE)

FACIAL MUSCLE

MENTAL PROTUBERANCE
(CHIN BONE)

*Forehead is formed by a single, curved line.*

*Forehead is formed by a line indented in the middle.*

## MALE VERSUS FEMALE FOREHEADS

All of the bones and joints on a man are slightly thicker and bigger than those of a woman's, and that includes the skull. But perhaps the biggest difference—aside from the more slender, delicate nose—is the forehead, which has a clear indentation on a man in the 3/4 view, but should be avoided in the female forehead in the same pose, as demonstrated above.

# HEAD ROTATIONS

If there is one exercise that can ferret out an art student's strengths as well as weaknesses, it would have to be head rotations. This is an excellent exercise to practice. Don't worry about the expression, simply draw a head in these various positions. By using the horizontal lines, you can spot check to be sure that each head maintains the correct proportions.

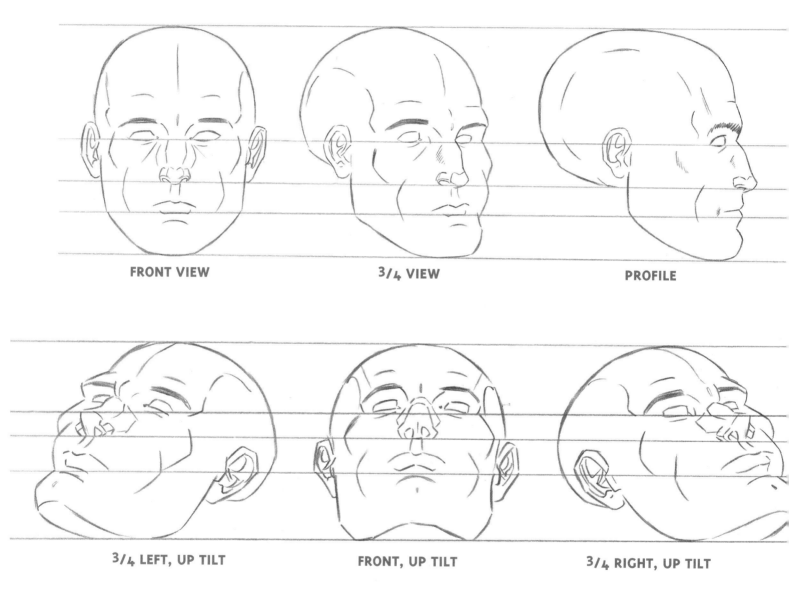

**FRONT VIEW**        **3/4 VIEW**        **PROFILE**

**3/4 LEFT, UP TILT**    **FRONT, UP TILT**    **3/4 RIGHT, UP TILT**

# FORESHORTENING AND THE HEAD

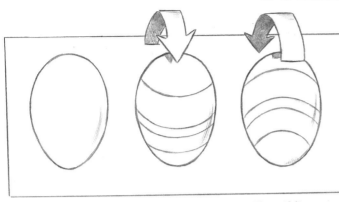

*The guidelines
curve upward*

*The guidelines
curve downward*

When the head tilts up or down, the length of the head and the features appear compressed. This is first accomplished by drawing curved guidelines on the face. To demonstrate this, look at the picture of the three eggs. The head is basically an egg shape. Look at the first egg, the one with no lines on it. Now look at the two eggs with guidelines drawn in. The second egg appears to be tilted down, while the third egg appears to be tilted back. Now get ready for the shocker: the last two eggs are identically drawn! Only their curved guidelines are different. That's right—on the egg that appears to be tilted down, the guidelines curve upward, and on the egg that is tilted back, the guidelines are curving downward. By using this same principle on the head, we can also create the illusion that the head is tilted down or back.

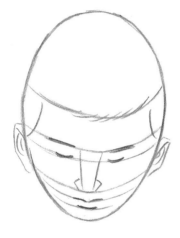

**BASIC CONSTRUCTION: LOOKING DOWN**

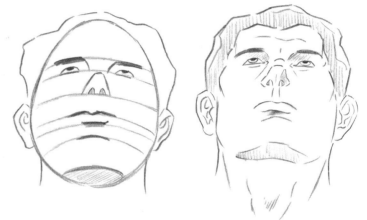

**BASIC CONSTRUCTION: LOOKING UP**

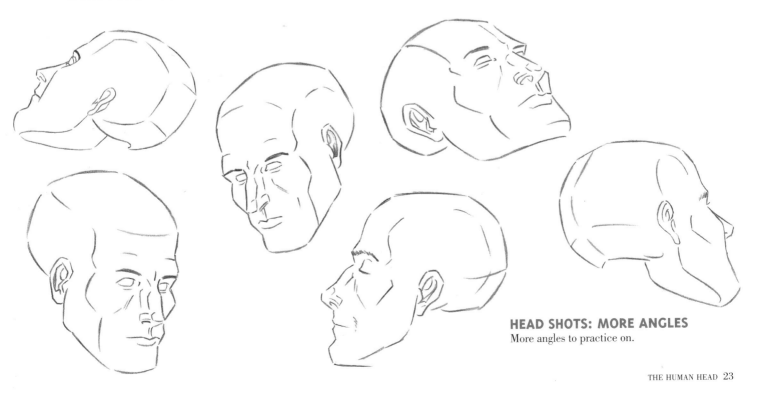

**HEAD SHOTS: MORE ANGLES**
More angles to practice on.

# THE FEATURES OF THE FACE

We've learned a good deal in the past chapter about the structure of the head and face. We're like architects who have designed a very good floor plan. But we still have to put something inside of the house. And in this metaphor, of course, I'm referring to the features of the face. Features are by and large varied, personal, and unique. However, we're going to generalize a bit, in order to give guidelines from which you can make adjustments according to your own style.

## THE EYE AND EYEBROW

The eye can prove difficult to draw unless you are aware of the way the upper and lower eyelids curve around the opened eye.

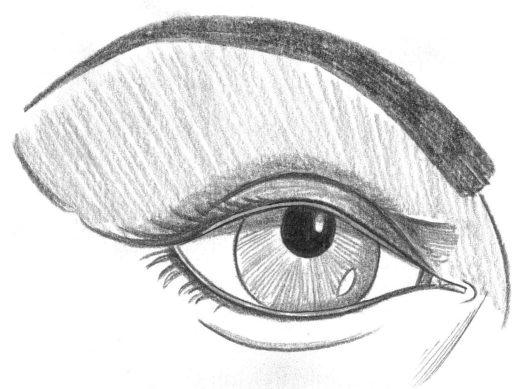

**THE DRAMATIC EYE**
A deft touch, attention to detail, and some shading are required to create a finished look.

## THE PARTS OF THE EYE

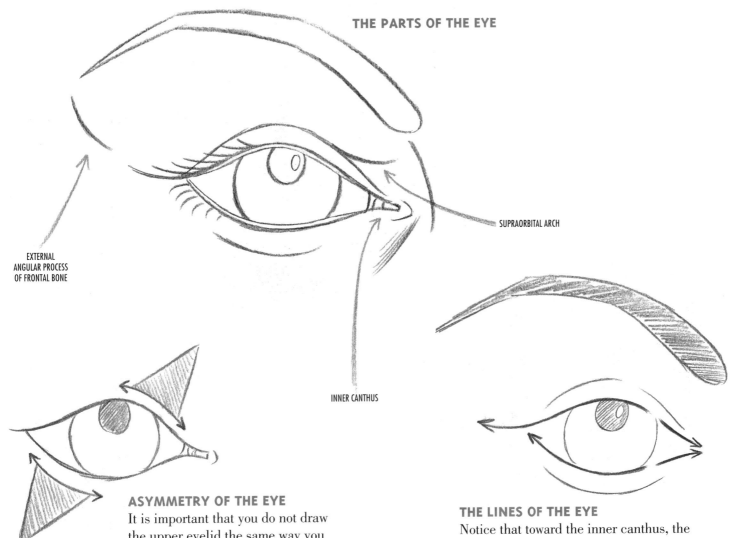

SUPRAORBITAL ARCH

EXTERNAL
ANGULAR PROCESS
OF FRONTAL BONE

INNER CANTHUS

### ASYMMETRY OF THE EYE
It is important that you do not draw
the upper eyelid the same way you
draw the lower eyelid. Each eyelid
crests at a different place. Note
the two bulges of the eyelids.

### THE LINES OF THE EYE
Notice that toward the inner canthus, the
lines are short and at a more severe angle.
Away from the inner canthus (toward the ear),
the lines are longer and at a gentler angle.
Notice that the top eyelid, as it sweeps
toward the ear, overlaps the lower eyelid.

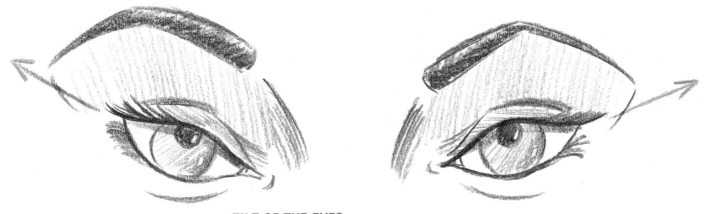

### TILT OF THE EYES
On women, it is appealing to raise the outer corner of the eyes,
so that the eyes appear to tilt inward toward the nose.

# DRAWING THE EYE IN PERSPECTIVE

When the head moves at a significant angle, such as the head of this woman, the shape of the eyeball must change with it. It's a good idea to lightly sketch a guideline under the eyes to make sure that they remain at one level. In this position, the eye is less round and more oval.

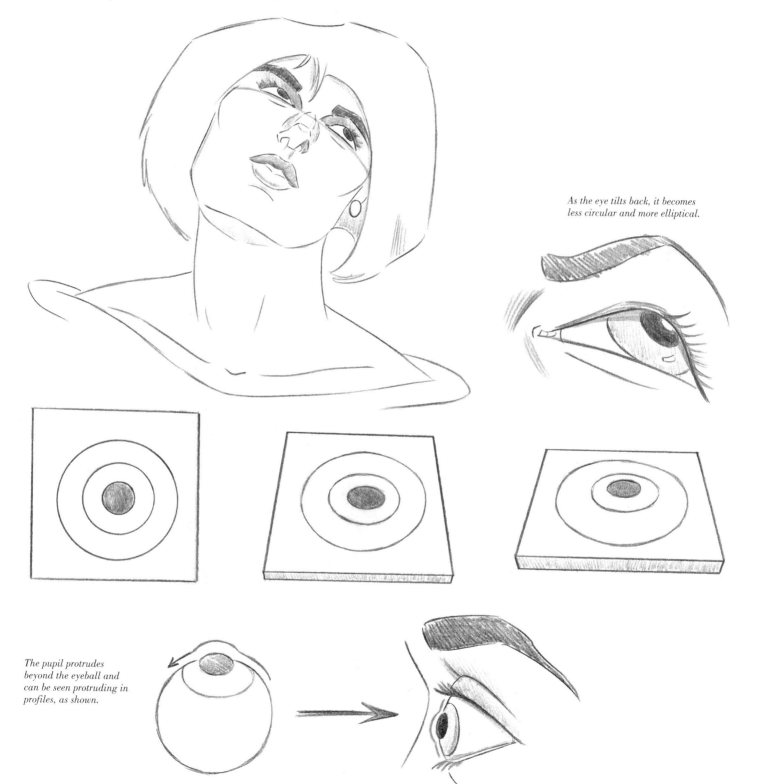

*As the eye tilts back, it becomes less circular and more elliptical.*

*The pupil protrudes beyond the eyeball and can be seen protruding in profiles, as shown.*

## THE ELLIPTICAL NATURE OF THE EYE IN PERSPECTIVE

In a 3/4 view, as opposed to a front shot, the eye is also elliptical, not round. Is this detail important? In itself, no, but a drawing is made up of many details, and the more accurate the sum of the details are, the more convincing your drawing will be.

# TYPES OF EYEBROWS

The eyebrows accentuate and underscore any expression. They open the eyes when they rise up and narrow them when they bear down. Without a strong eyebrow, the eye tends to lose impact. Here are some common types of eyebrows. Note that the upper eyelid casts a small shadow on the eye itself. This touch adds depth and interest to the eye.

**WOMEN'S EYEBROWS**

CLASSIC, SHORT

THICK, SHORT

*Note that the outside is higher than the inside.*

CLASSIC, LONG

THICK, LONG

HIGH, LOOPING

IRREGULAR

**MEN'S EYEBROWS**

HIGH BACK

ANGLED

BUSHY

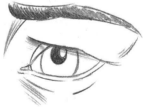

THIN

SEVERE

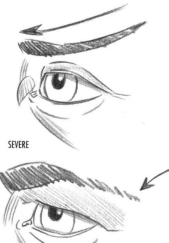

BROKEN

# THE NOSE

The nose is the only feature of the face that sticks out from the face plate and becomes a separate structure. It therefore draws attention to itself if it isn't illustrated correctly. The nose is comprised of several sections with many angles, not just a straight line.

BRIDGE OF NOSE (BONE)

LONG SECTION OF NOSE (CARTILAGE)

END OF NOSE (CARTILAGE)

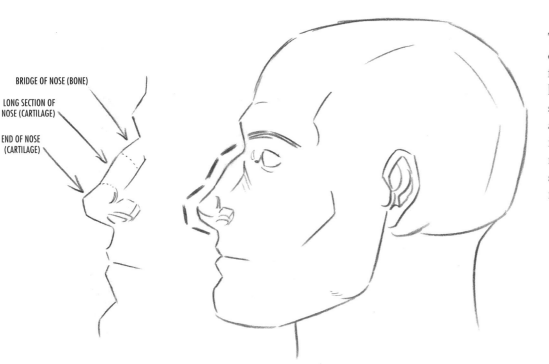

## SECTIONS OF THE NOSE

The nose is divided into three sections: the bridge of the nose, which is the bony part of the skull; the cartilage; and the ball of the nose, which is, as we will see in the next page, two pieces of cartilage joined together.

## THE ANGLES OF THE NOSE

The angle of the nose changes at each point that a piece of bone or cartilage connects to another piece of cartilage.

## DEPTH OF THE NOSE

This is vitally important. The nose is not flat. Therefore, you must draw it as if it has sides to it, because in fact it does.

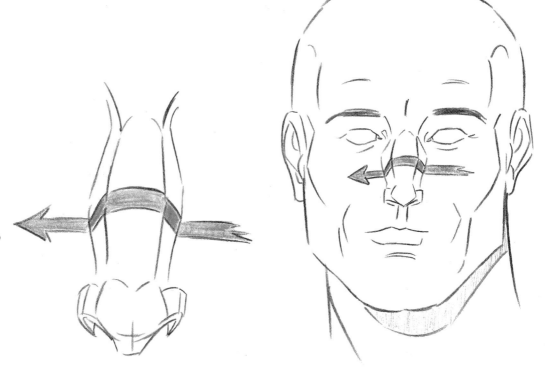

# DECONSTRUCTING THE NOSE

Everyone focuses on the eyes, yet the nose is a more complex structure, which
can nonetheless be simplified by breaking it down into its elements.

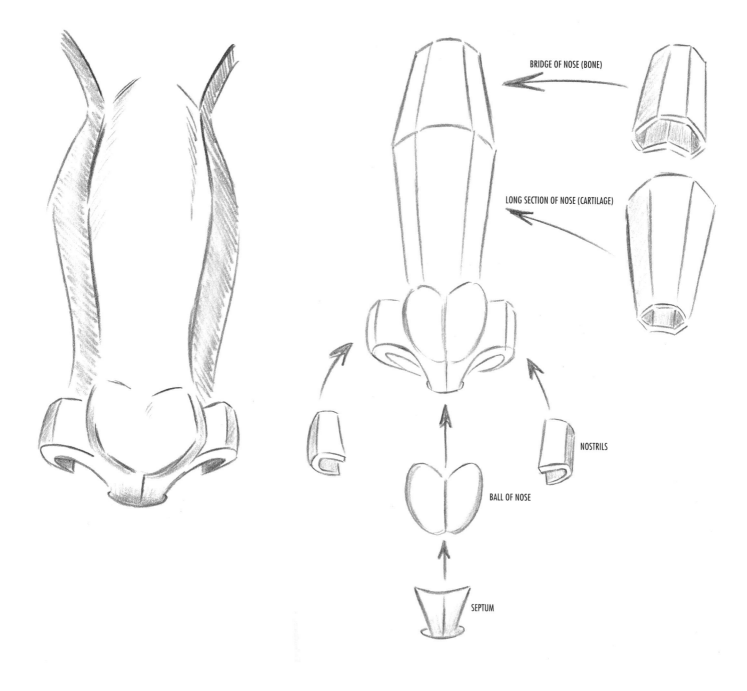

BRIDGE OF NOSE (BONE)

LONG SECTION OF NOSE (CARTILAGE)

NOSTRILS

BALL OF NOSE

SEPTUM

# THE NOSE FROM VARIOUS ANGLES

Just as an art student will practice drawing the head from various angles, he or she must equally practice drawing the features of the face from various angles.

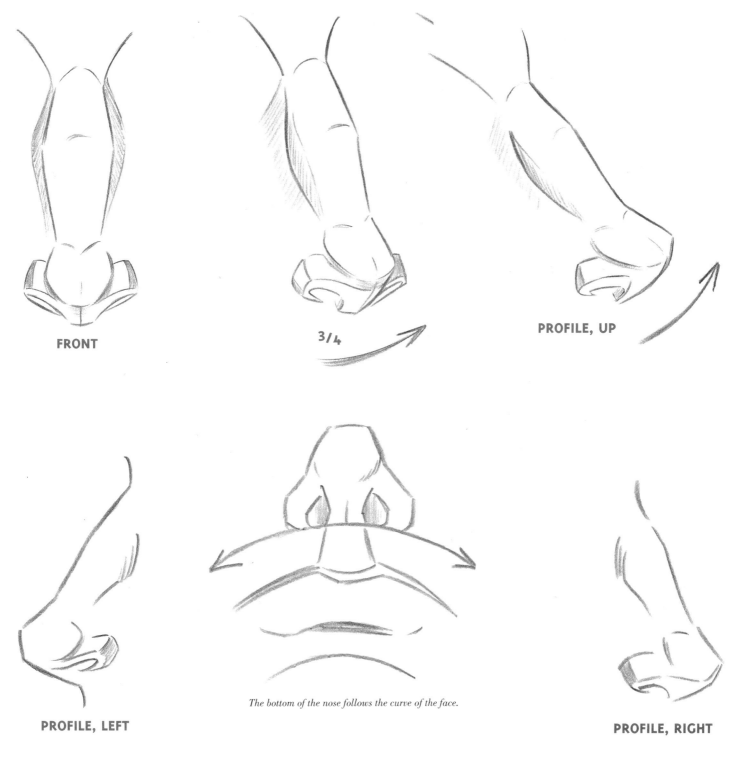

**FRONT**

**3/4**

**PROFILE, UP**

*The bottom of the nose follows the curve of the face.*

**PROFILE, LEFT**

**PROFILE, RIGHT**

# EXAMPLES OF OTHER NOSES

Women's noses are constructed the same way as a man's, however, the angles are much less sharp. It's a good idea to leave out the angle where the bridge of the nose attaches to the cartilage, and instead, draw it as a straight line. However, the ball of the nose can be accentuated. Women's noses, by and large, are drawn by leaving details out, thereby softening the look. Other noses may be adjusted to create other looks.

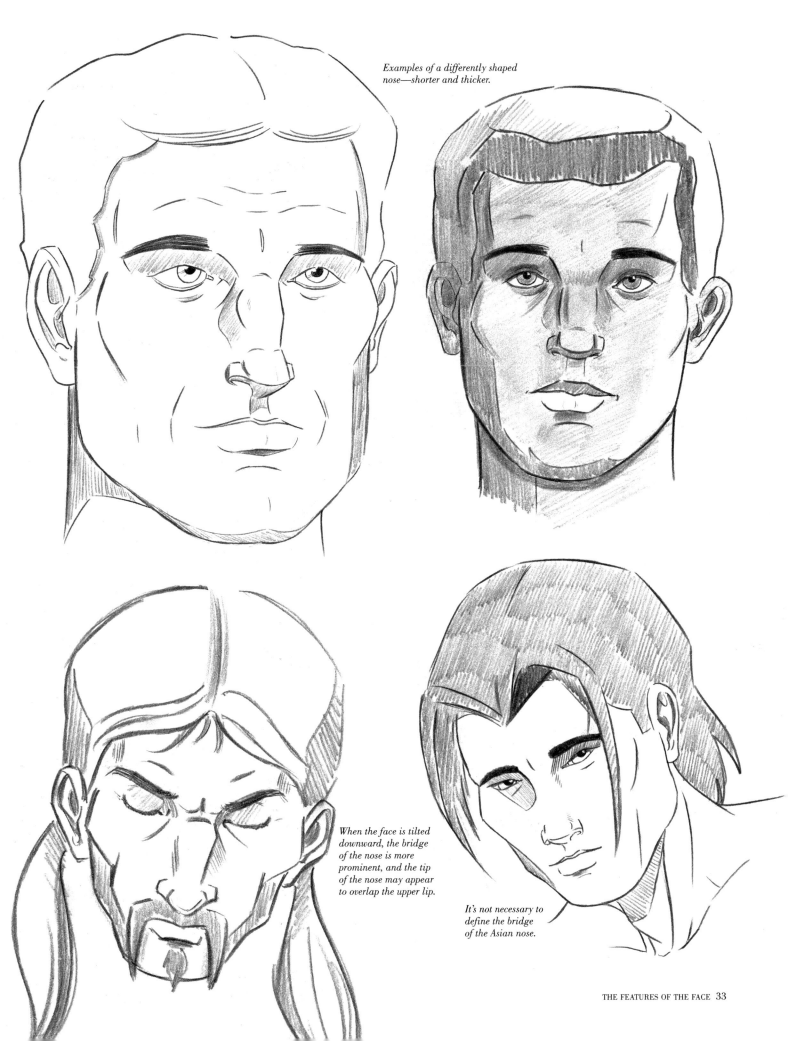

*Examples of a differently shaped nose—shorter and thicker.*

*When the face is tilted downward, the bridge of the nose is more prominent, and the tip of the nose may appear to overlap the upper lip.*

*It's not necessary to define the bridge of the Asian nose.*

# THE LIPS

The lips are a rather simple form. Therefore, it's important not to skip over this area, because learning this material will so easily bear fruit. The lips are created by gently curving lines that are pleasing to the eye. The curves are subtle, but the line should be bold. Let's take a look at the basics.

The bottom lip is divided into two masses, whereas the top lip can be divided into three.

In some poses the top and bottom lips, when closed, will appear to join at the ends, but more often, closer inspection will reveal that the top lip overlaps the bottom.

Both top and bottom lip indent in the middle, toward each other.

The top lip extends beyond the bottom lip.

The top lip is usually darker, because of the cast shadow from overhead light. The bottom lip is usually lighter, as it reflects the light.

# SMILES, AND THE SHAPE OF THE LIPS

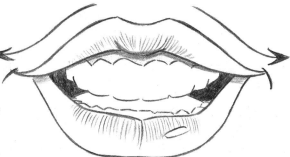

**I. DOWNWARD SMILE WITH UPTURNED ENDS**
This is perhaps the most common type of smile. The bottom lip curves up, but the top lip curves down, until the very end, where it curves up slightly.

There are many types of smiles, and only one of them is the classic "happy face" where the upper lip and the bottom lip both curve upward in the extreme. More often, there is some downturn in the upper lip, even in a smile. This in no way dampens the cheerfulness of the expression. The smile expression is more a result of the upward curve of the lower lip, not the upper lip. The most appealing smiles show teeth, with just a hint of the upper gums. Too much gum is unappealing. Observe a few common examples here.

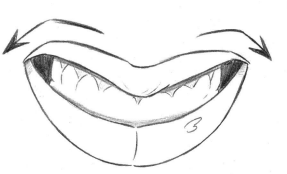

**2. DOWNTURNED SMILE, WITH DIP IN THE MIDDLE**
Surprisingly, the down turned smile is one of the most appealing and thoroughly happy smiles. This smile is most effective if there are small pockets of space left between the teeth and the sides of the mouth.

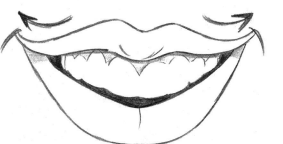

**3. UPTURNED SMILE**
Despite popular belief, this is not the smile that most people make, but some do, so it's worth addressing. The sharp upward turn of the upper lip must begin early, or you end up with smile #1.

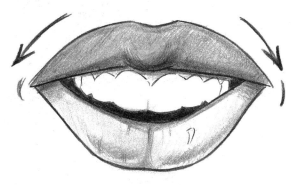

**4. DOWNTURNED SMILE**
The upper lip is shaped like a horizontal crescent moon.

# MEN'S LIPS

Many people draw men's lips as a straight line, fearful that full lips will feminize the character. And while it is true that full lips would not work on a man, there is a method of drawing a man's mouth that makes it appear more realistic than two simple lines do, at the same time retaining the masculinity of the subject.

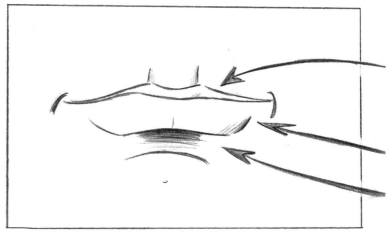

*The top lip has a minimal amount of thickness.*

*The bottom lip does not attach to the top lip, but remains open.*

*A shadow forms under the middle of the bottom lip.*

## THE ELEMENTS OF A MAN'S LIPS

The upper lip should have some thickness in the middle, but quickly becomes very thin at the sides, thinning to a single line at the ends. The ends of the bottom lip should not attach to the top lip, as they do on a woman's, but should instead remain open.

## A MAN'S MOUTH IN PROFILE

Notice the slight rise toward the back of the lips, which gives a rugged look. Also note that the teeth recede from the end of the lips.

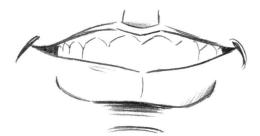

### SMILE
Downturned upper lip, with a slightly upturned lower lip.

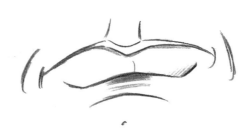

### FROWN
Upper lip pushes down while lower lip pushes up at the middle. There are several creases at the sides of the mouth.

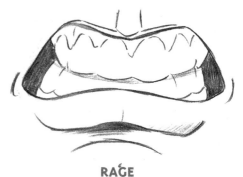

### RAGE
Widely stretched lips, revealing large pockets on either side of the bottom teeth. Lower lip peaks in the middle, as upper lip dips in the middle. Upper teeth overlap lower teeth.

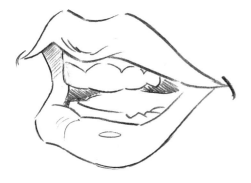

Practice a few of these, and you should find yourself internalizing the idea rapidly. Some artists use a desktop mirror to model their own expressions.

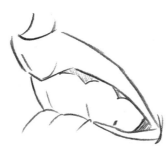

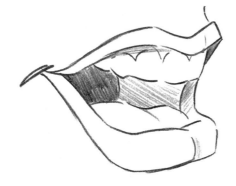

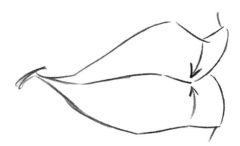

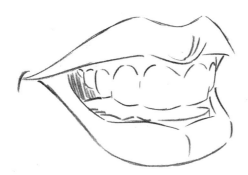

# THE EAR

Although I can demonstrate step by step how to draw the ear, it remains a difficult task no matter how one slices it. This small part of the body is precisely formed with many curves and crannies in order to bring us the richest volume of sound possible. We can clarify the patterns of the ear, thereby making it easier to reproduce.

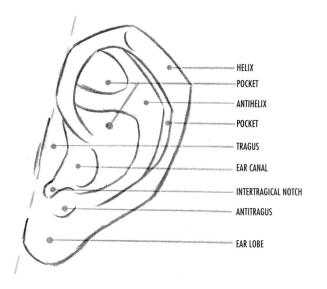

## DIAGRAM OF THE EAR
Do not memorize this. I include this simply to demonstrate that the ear, although it may look like a jumble of lines that can be fudged, actually has a specific pattern that must be followed. That being said, all ears differ. Some are wider, some curl more, or less, some have long or short earlobes. But they all have these identifiable parts, which are labeled below.

HELIX
POCKET
ANTIHELIX
POCKET
TRAGUS
EAR CANAL
INTERTRAGICAL NOTCH
ANTITRAGUS
EAR LOBE

## THE EAR, STEP BY STEP
Taking the ear piecemeal, starting with the outline of the ear, and working our way inward, will be the easiest method.

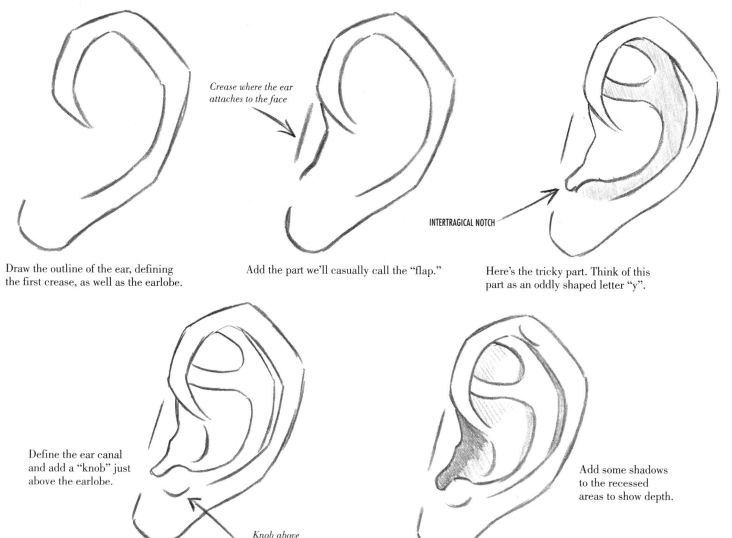

Draw the outline of the ear, defining the first crease, as well as the earlobe.

*Crease where the ear attaches to the face*

Add the part we'll casually call the "flap."

INTERTRAGICAL NOTCH

Here's the tricky part. Think of this part as an oddly shaped letter "y".

Define the ear canal and add a "knob" just above the earlobe.

*Knob above earlobe*

Add some shadows to the recessed areas to show depth.

# MORE ANGLES OF THE EAR

Some examples of the ear in common positions:

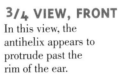

**REAR VIEW**
Note the cuplike attachment of the ear to the head, which can only be seen in this view.

**3/4 VIEW, FRONT**
In this view, the antihelix appears to protrude past the rim of the ear.

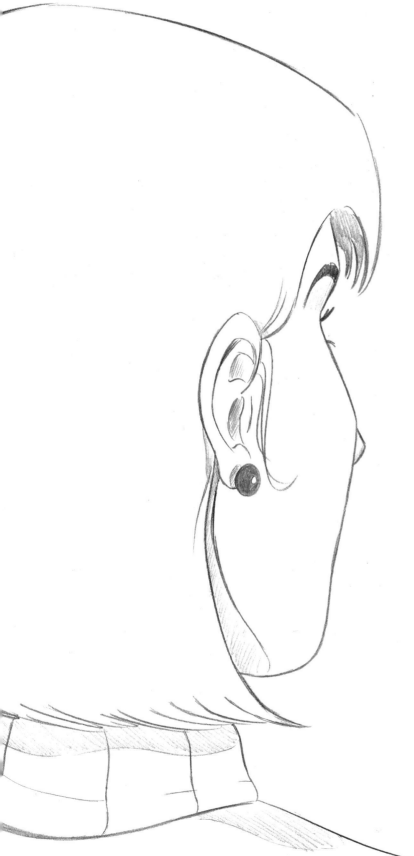

**SIDE VIEW, RIGHT**
Here is another example of the profile.

# PUTTING IT ALL TOGETHER

Now that we have familiarized ourselves with the shape of the skull, the proportions of the face, the planes of the face and the features, let's put it all together from scratch, using our newfound knowledge. In the opening chapter, we outlined the head before adding the features, then padded the sides of the cranium to give it more width. This time, let's add the extra width at the outset.

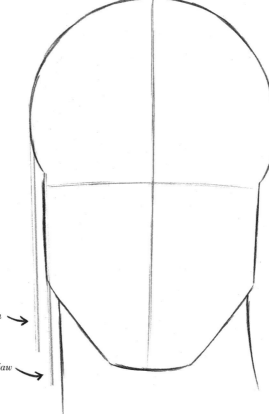

**1**

Start with the outline of the head. Lightly sketch the guidelines.

*Width of the cranium* →

*Width of the jaw* →

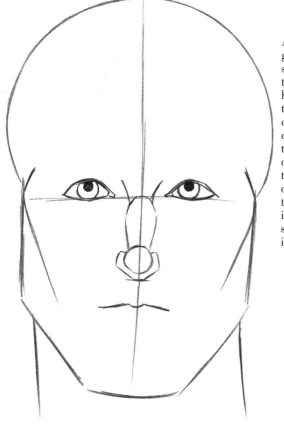

**2**

Add the eyes along the horizontal guidelines. Build the nose in segments. The cheekbones flow toward the mouth. Every person has unique features. I've given this man a small mouth and wide cheekbones. As a result, the cheekbones will not flow directly to the edges of the lips, as they do on many other people, but they still flow in that general direction. Small changes such as this one, as long as they do not interfere with the anatomy of the subject, are what make individuals unique.

**3**

Continue to define the skull's temporal ridge (the indented, curved sides of the skull) and chin. Add eyebrows. This fellow has eyebrows that rest right on top of the eyes. Other people may have more room between the eyes and eyebrows, another individual trait. Blend the segments of the nose into one form. Flesh out the lips.

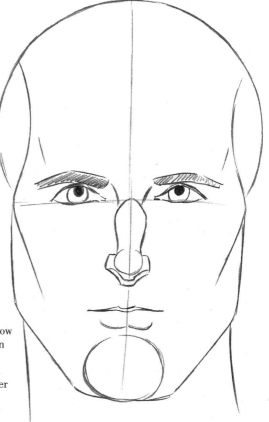

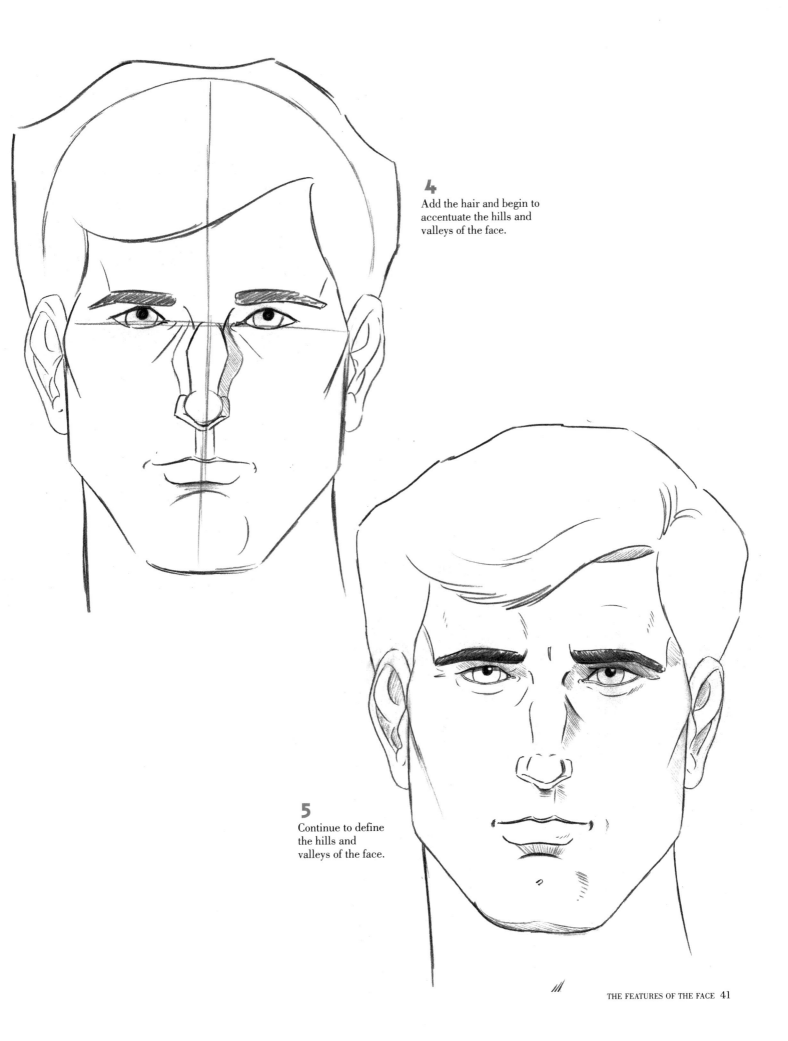

**4**
Add the hair and begin to accentuate the hills and valleys of the face.

**5**
Continue to define the hills and valleys of the face.

# THE ANGLED HEAD

This head is tilted slightly upward, which gives the subject an interesting mood. Because of the tilt, we will see more of the underside of the nose, and a bit of the underside of the chin. In addition, the top of the head (skull) will appear to be smaller in comparison to the jaw section, due to the tilt of the head. Notice that the bridge of the female nose makes a much less pronounced break from the rest of the nose than the male's.

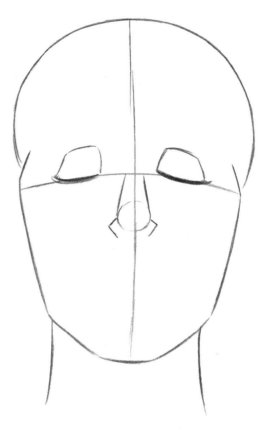

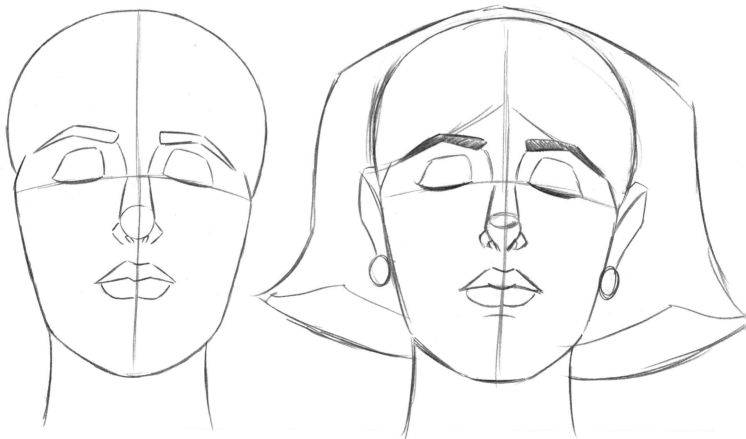

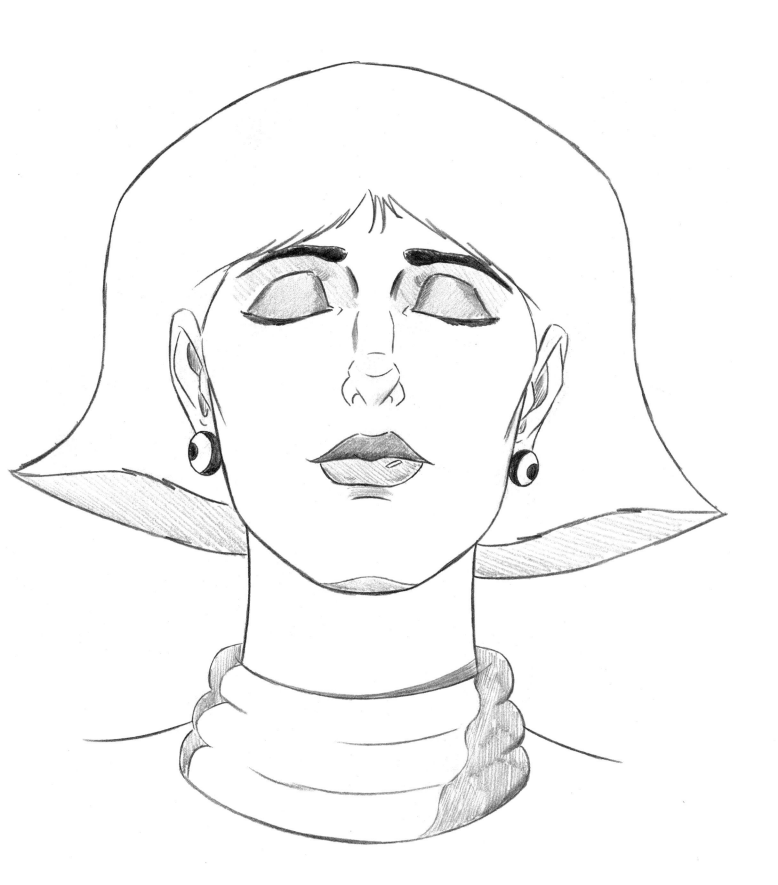

# CREATING UNIQUE CHARACTERS

Notice how minor alterations in the basic structure of the head result in a significantly different person. The shape of this woman's head started out with more pronounced cheekbones, a sharper angle of the jaw, and a more angular chin.

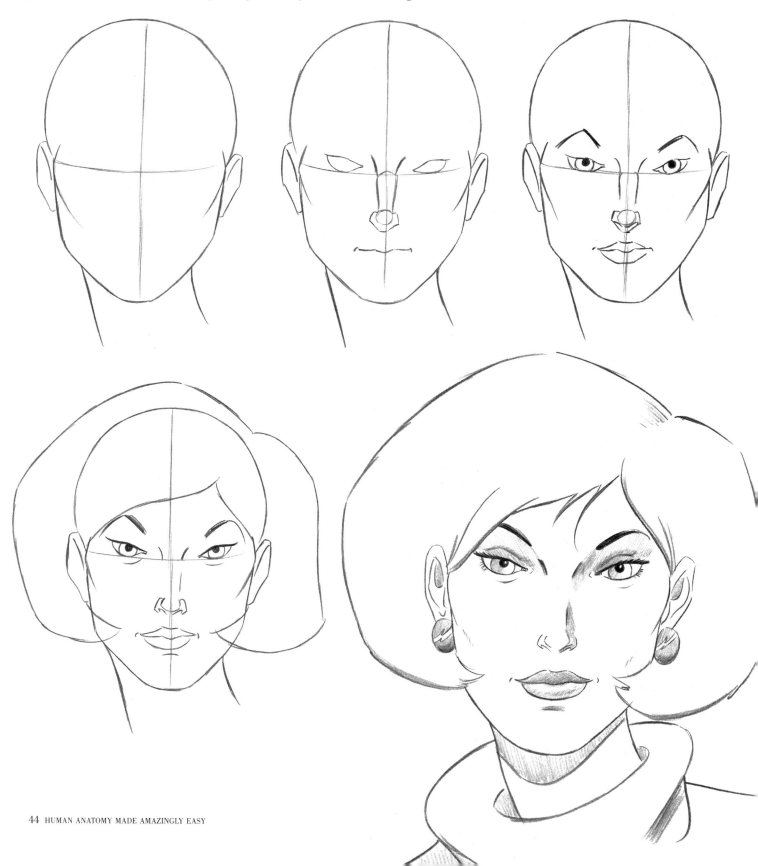

# CARICATURE AND ANATOMY

Exaggerating the actual anatomy of the head and following the patterns of creases left by expression marks can turn a realistic drawing into a cartoon creation.

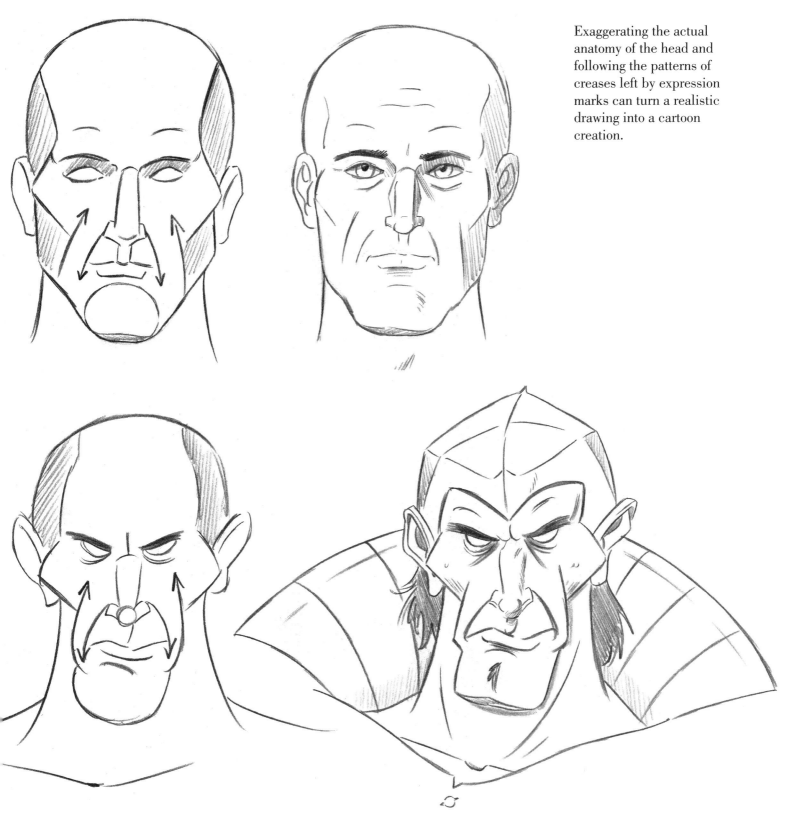

# THE SKELETAL STRUCTURE

The skeleton is truly the foundation of the body, from an artist's point of view. As we continue in this book, it will become readily apparent to you why a familiarity with the skeleton is essential to drawing the figure.

## THE BONES OF THE LIMBS

All of the bones of the limbs have the same pattern: one bone on top, two bones below. Note that the top, single bones are heavier than the double bones below. Also notice that the leg bones are much more substantial than the arm bones. That's because they are weight-bearing bones. All bones and joints designed to be weight bearing are more massive. The skeleton is truly a marvelous piece of engineering.

SINGLE BONE

DOUBLE BONES

SINGLE BONE

DOUBLE BONES

# THE SKELETON: Proportions

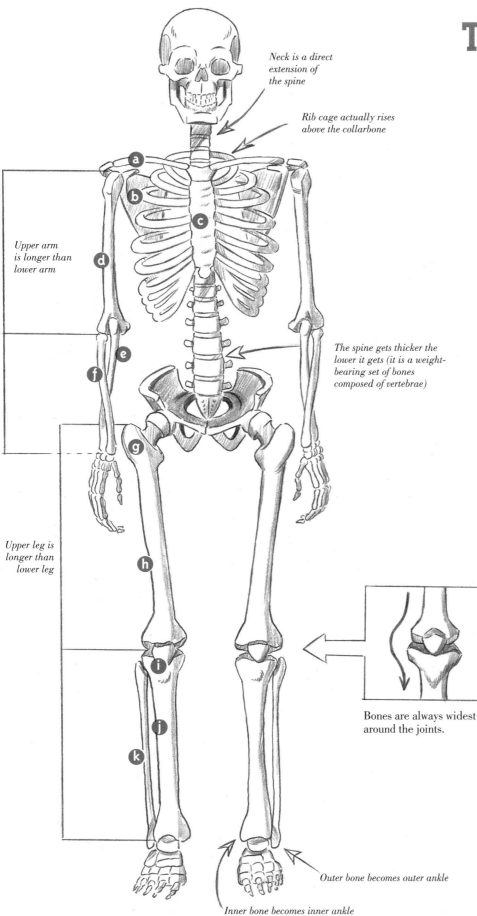

*Neck is a direct extension of the spine*

*Rib cage actually rises above the collarbone*

*Upper arm is longer than lower arm*

*The spine gets thicker the lower it gets (it is a weight-bearing set of bones composed of vertebrae)*

*Upper leg is longer than lower leg*

*Bones are always widest around the joints.*

*Outer bone becomes outer ankle*

*Inner bone becomes inner ankle*

Here's the typical skeleton, although even here, there's no universal standard. All skeletons are different, the way that all faces are different. But again, we must work from an idealized standard, so this one will be it. Let's call him Slim.

## IDENTIFYING THE BONES

It can only be beneficial to know most of the bones by name, but it's not critical. They are identified mainly so that we can refer to them in future pages.

a  clavicle (collarbone)
b  scapula (shoulder blade)
c  sternum (chest bone)
d  humerus (upper arm bone)
e  ulna (forearm bone on little finger side)
f  radius (forearm bone on the thumb side. Note that the radius is shorter than the ulna.)
g  great trochanter
h  femur (thigh bone)
i  patella (kneecap)
j  tibia (shinbone)
k  fibula

# THE SIMPLIFIED SKELETON:
## Self-checking the Proportions

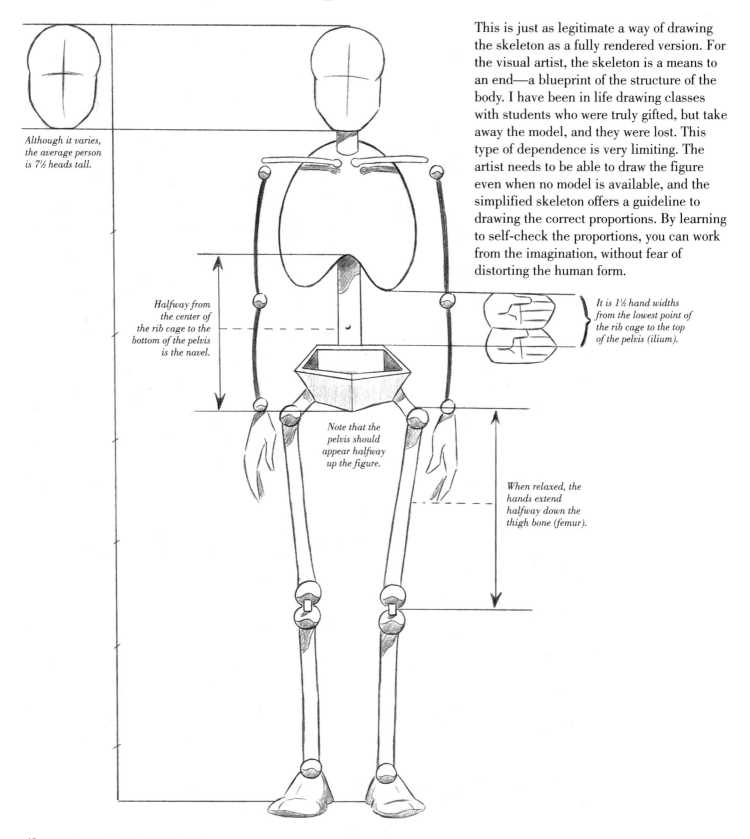

*Although it varies, the average person is 7½ heads tall.*

*Halfway from the center of the rib cage to the bottom of the pelvis is the navel.*

*Note that the pelvis should appear halfway up the figure.*

This is just as legitimate a way of drawing the skeleton as a fully rendered version. For the visual artist, the skeleton is a means to an end—a blueprint of the structure of the body. I have been in life drawing classes with students who were truly gifted, but take away the model, and they were lost. This type of dependence is very limiting. The artist needs to be able to draw the figure even when no model is available, and the simplified skeleton offers a guideline to drawing the correct proportions. By learning to self-check the proportions, you can work from the imagination, without fear of distorting the human form.

*It is 1½ hand widths from the lowest point of the rib cage to the top of the pelvis (ilium).*

*When relaxed, the hands extend halfway down the thigh bone (femur).*

# THE SKELETON: Back View

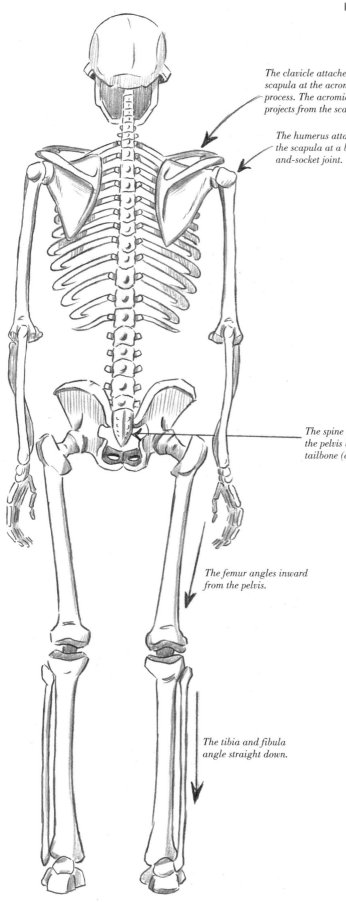

*The clavicle attaches to the scapula at the acromion process. The acromion process projects from the scapula.*

*The humerus attaches to the scapula at a ball-and-socket joint.*

*The spine extends into the pelvis by way of a tailbone (coccyx)*

*The femur angles inward from the pelvis.*

*The tibia and fibula angle straight down.*

Now let's make some observations that will come in useful when drawing the figure from the rear:

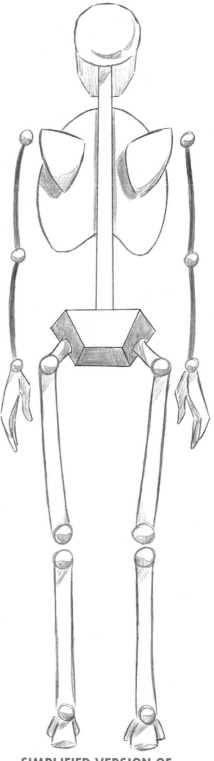

**SIMPLIFIED VERSION OF SKELETON: BACK VIEW**

# THE SIMPLIFIED SKELETON: Side View

Note the curves of the neck, spine, upper and lower legs. Notice, too, how the curves connect together seamlessly, without sharp angles. There is a sweep and a flow to the entire body. Try to feel it when you sketch a figure. We will get into the flow of the body in more detail in future chapters.

The male pelvis tilts forward slightly, while the female pelvis tips forward to a greater degree.

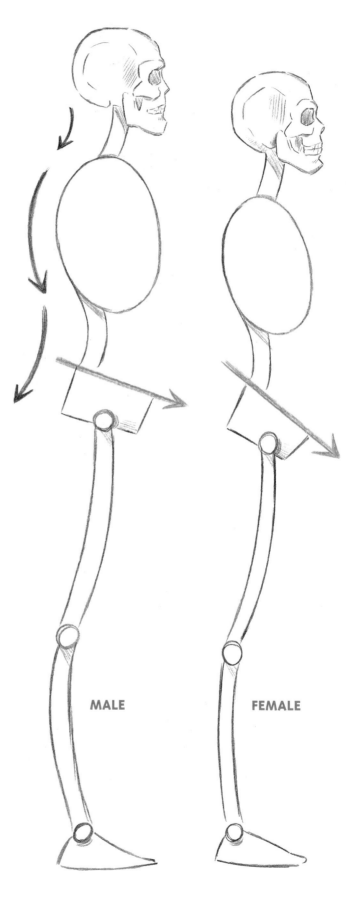

MALE          FEMALE

# COMPARATIVE ANATOMY: Male and Female Pelvis

The male pelvis is narrower in width and taller in length than the female. The female pelvis is wider and shorter than the male. The result of the greater width of the female pelvis is that it accentuates the indentation between the widest part of the pelvis and the great trochanter. The male doesn't share this indentation.

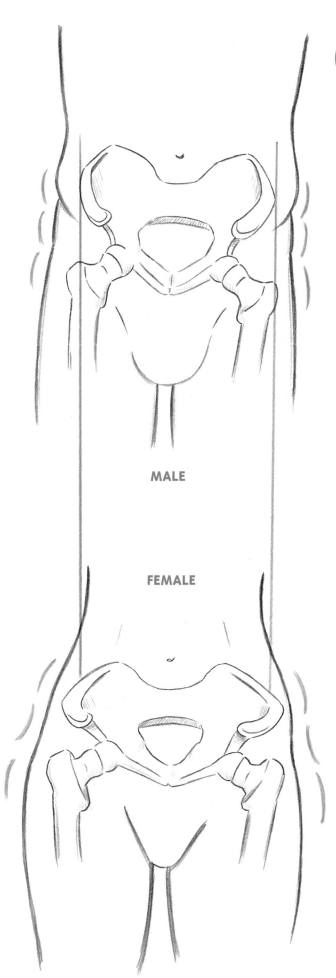

**MALE**

**FEMALE**

The male pelvis is narrower and taller, while the female pelvis is wider and shorter.

# BONES THAT SHOW THROUGH THE BODY: Front View

Another important reason for not ignoring the construction of the skeleton is that it becomes visible at many points on the body. People are used to seeing the skeleton create bumps and bulges in the skin, and tug on clothing this way and that. Therefore, let's take a look at the most common places in the body where the skeleton protrudes:

a exterior malleolus (of the fibula)
b tibia
c patella
d heads of metacarpals (knuckles)
e joint at base of thumb
f clavicle

g anterior superior iliac spine (of the pelvis)
h thorax (rib cage)
i medial epicondyle (of the humerus)
j olecranon process (part of the ulna)
k head of ulna (wrist joint)
l acromion process (of the scapula)

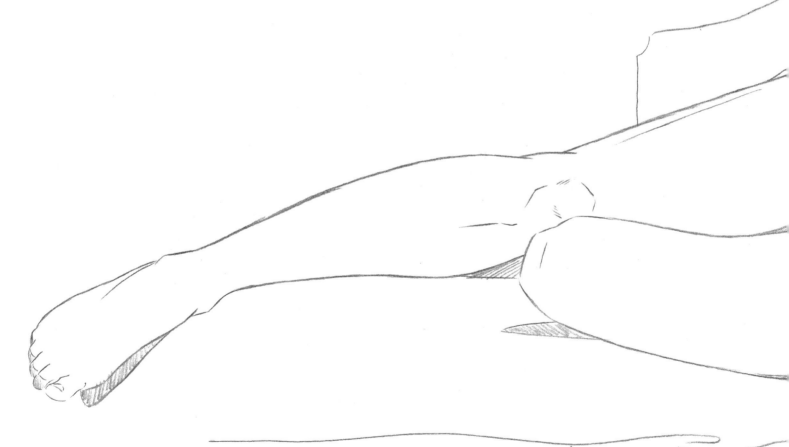

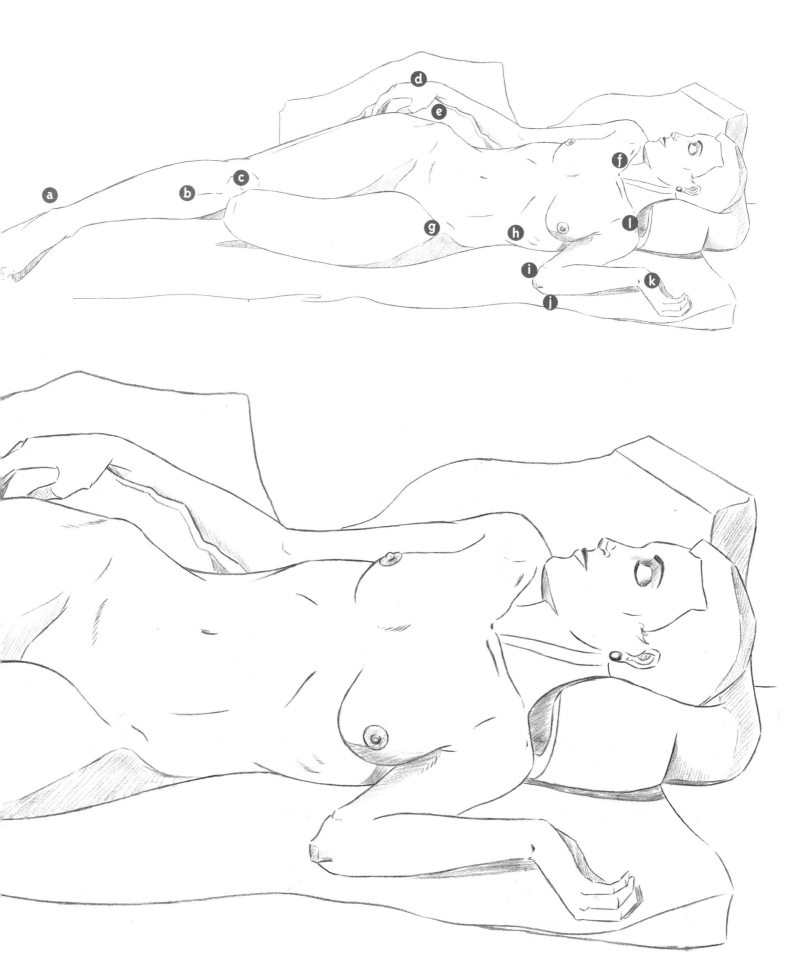

# BONES THAT SHOW THROUGH THE BODY: Back View

Because people carry far less weight on their back than they do on the front, you will usually find a good amount of show-through bones even on non-athletic types.

a seventh cervical vertebra
b spine of the scapula
c acromion process
d scapula
e thorax (rib cage)
f medial epicondyle
 (at the base of the humerus)
g olecranon process
h sacrum
i head of fibula
j exterior malleolus of fibula
 (outer ankle)

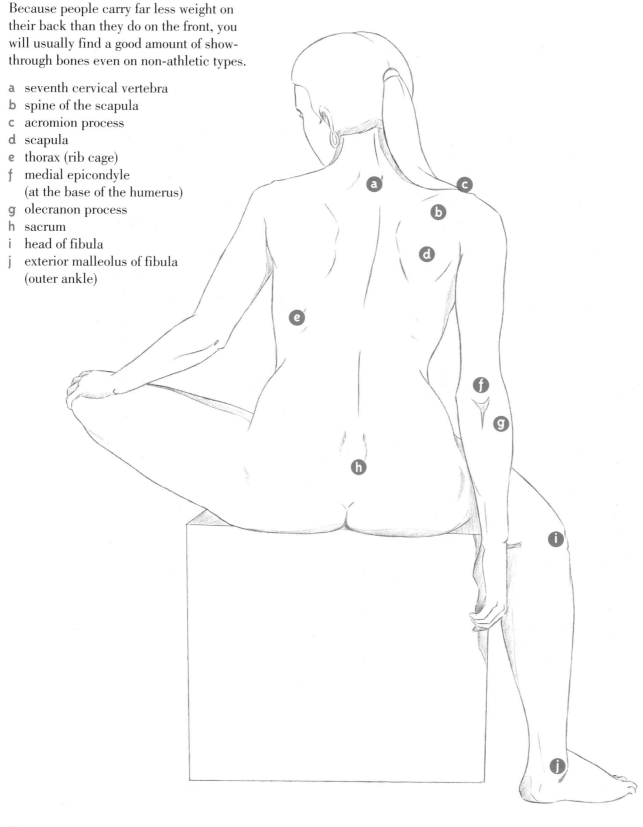

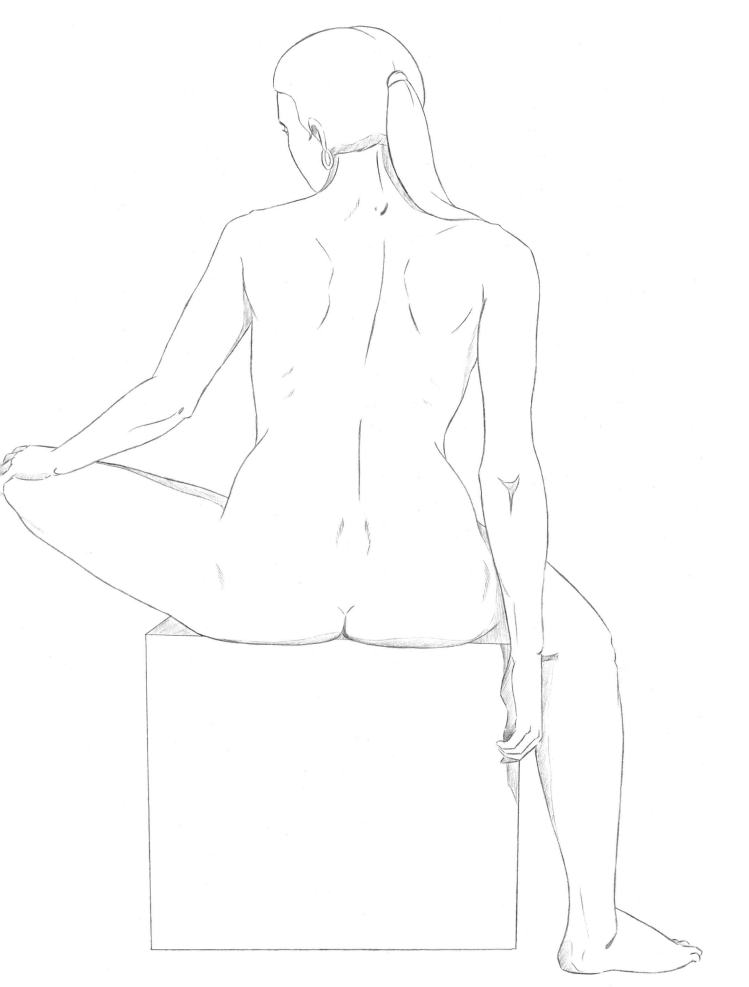

# THE SIMPLIFIED FIGURE

Few artists begin a drawing with the skeleton and every sinewy fiber of muscle. More often, they first sketch the entire figure, which they then refine using their knowledge of anatomy. These sketchy poses should not be constrained, but should have bold, careless lines. Strive for the feeling of the pose, rather than accuracy. If the initial sketch has life to it, then the refined sketch will as well. But no amount of studied accuracy can substitute for a good feel of the pose.

# PLANES OF THE BODY

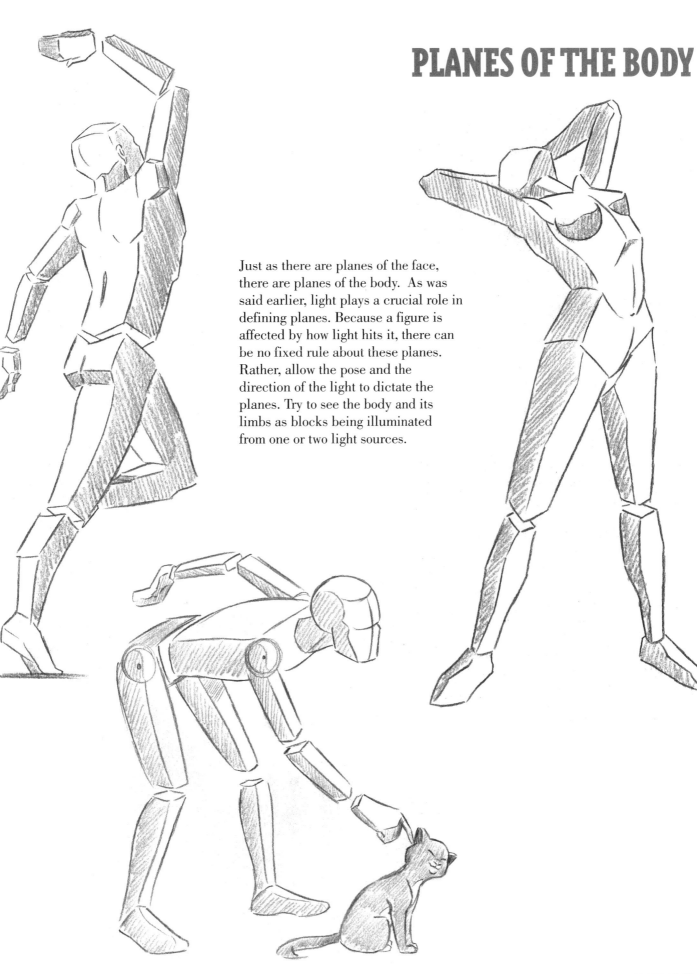

Just as there are planes of the face, there are planes of the body. As was said earlier, light plays a crucial role in defining planes. Because a figure is affected by how light hits it, there can be no fixed rule about these planes. Rather, allow the pose and the direction of the light to dictate the planes. Try to see the body and its limbs as blocks being illuminated from one or two light sources.

# THE FEATURES OF THE BODY

## THE MAJOR MUSCLES

Many of the muscles are no doubt already familiar to you, such as the biceps and triceps of the arm, the major chest muscles, the inner calf muscle, and so forth. We see them every time we look in the mirror, or at a health club. What's important is to notice the length of the muscles and how they are interwoven into the surrounding muscles.

a  sternomastoid
b  deltoid
c  pectoralis major
d  biceps
e  teres major
f  serratus
g  external oblique
h  rectus abdominis
i  gracilis
j  sartorius
k  quadriceps
l  gastrocnemius
m  soleus
n  tibialis
o  peroneus longus

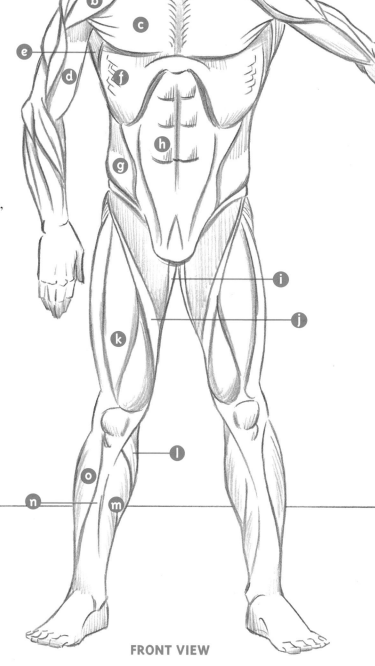

**FRONT VIEW**

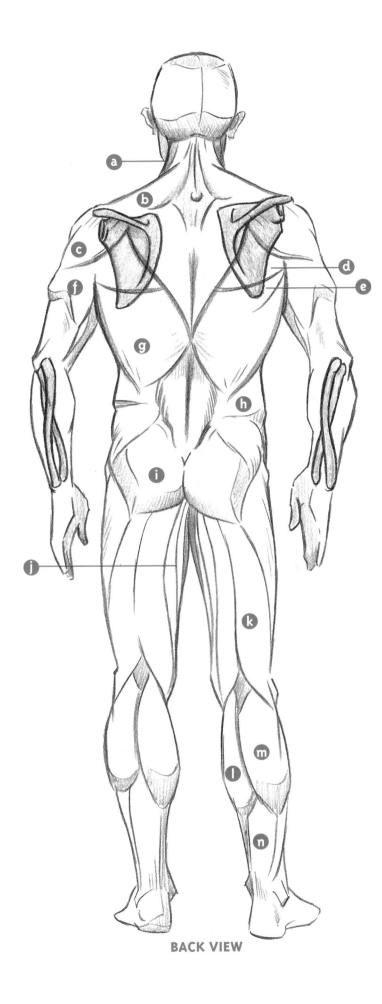

Note the position of the shoulder blades, which are attached to both the shoulder muscles and the trapezius muscle, and which are, at the bottom, partially covered by the latissimus dorsi muscles. Note that the forearm is composed of two bones twisted over each other. We will cover this in more detail in an upcoming chapter.

a   sternomastoid
b   trapezius
c   deltoid
d   teres minor
e   teres major
f   triceps
g   latissimus dorsi
h   external oblique
i   gluteus maximus
j   gracilis
k   biceps femoris
l   gastrocnemius *(medial head)*
m   gastrocnemius *(lateral head)*
n   achilles tendon

**BACK VIEW**

# KNOWING YOUR MUSCLES

You might ask, why must I be familiar with all the curves of the muscles? Can't I just draw the figure without it? Every artist has lamented this. Unfortunately, the answer is that knowledge of the contours of the muscles is essential. Let's see why.

## FIGURE DRAWN WITHOUT KNOWLEDGE OF ANATOMY

In this figure, the proportions are correct, but the musculature is not understood. The artist knows that there are some indentations on the chest, near the clavicle, and by the shoulder. The artist sees them, but can only guess their direction, because he cannot see what has formed them, that which is buried beneath the skin and fat.

MUSCLE ABOVE CLAVICLE

CHEST MUSCLE

SHOULDER MUSCLE

## FIGURE WITH MUSCULATURE

By taking a quick glance at the actual muscles, you can quickly see the mistake. Yes, indentations are placed where they should be, but the path of the muscles is all wrong.

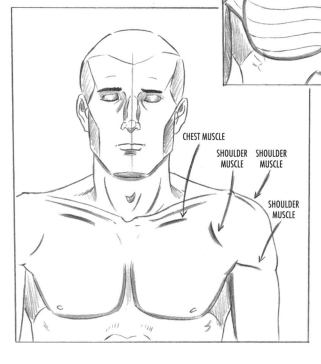

CHEST MUSCLE

SHOULDER MUSCLE  SHOULDER MUSCLE

SHOULDER MUSCLE

## CORRECTED FIGURE

Now we're adding accents to the muscles in the directions that they are traveling, resulting in a more accurate rendering of the figure.

# SHADOWS CREATED BY THE MUSCLES

As muscles peak at various points along the body, they cast small shadows, which help to define their presence. It's important not to be a slave to the anatomical structure of the body. You do not have to, nor should you, indicate every muscle in the body. But the major muscle groups should be recognizable.

# THE MUSCLES OF THE NECK

There are many muscles in the neck. We will focus only on those that are observable to the naked eye. Most people have necks that readily reveal the musculature. Furthermore, the muscles of the neck are surprisingly thick and strong, which is only natural, because it must carry a weighty skull upright for sixteen hours a day. Among the muscles of the neck are pockets of space, which help to define the muscles.

a  sternohyoid (shows mainly when the head is tilted back)
b  sternomastoid (most noticeable muscle of the neck)
c  sternomastoid (it splits off and attaches further up the clavicle)
d  trapezius (visible from the front, this muscle also travels down to the middle of the back)

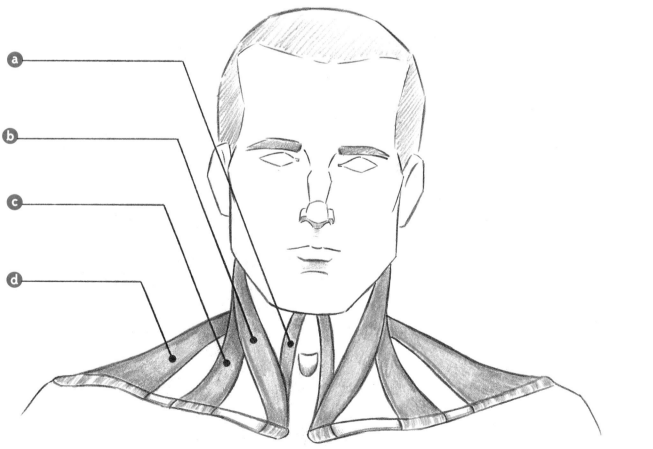

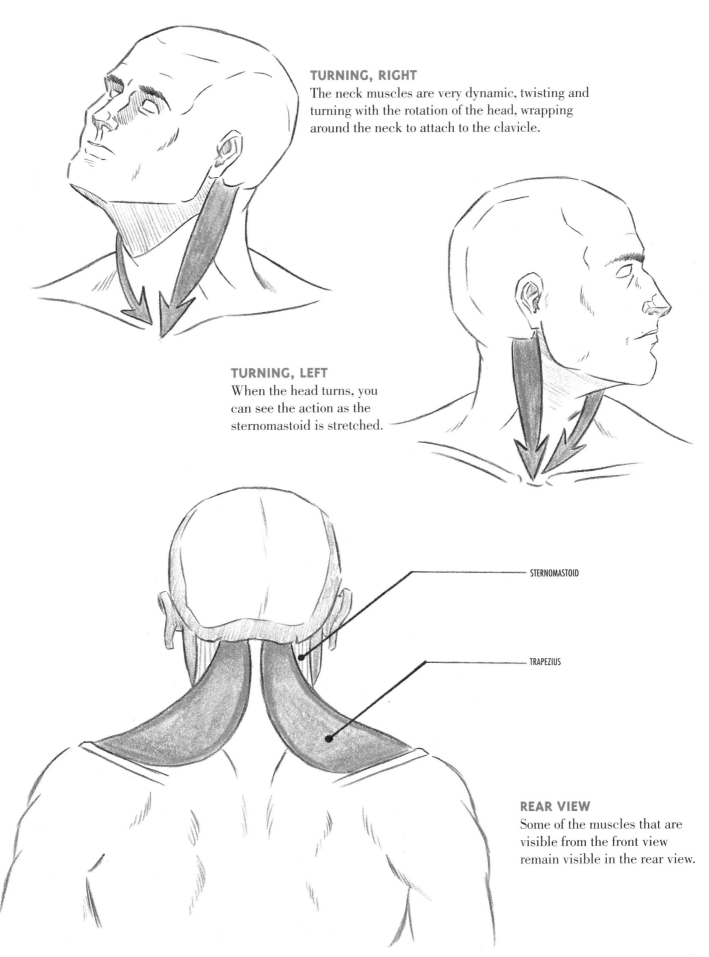

**TURNING, RIGHT**
The neck muscles are very dynamic, twisting and turning with the rotation of the head, wrapping around the neck to attach to the clavicle.

**TURNING, LEFT**
When the head turns, you can see the action as the sternomastoid is stretched.

STERNOMASTOID

TRAPEZIUS

**REAR VIEW**
Some of the muscles that are visible from the front view remain visible in the rear view.

# THE MUSCLES OF THE ARM

As you can see, there are more to the arms than the biceps and triceps, although they are by far the most dominant muscles of the upper arm. Of particular importance is the coracobrachialis of the inner side of the arm and the brachialis of the outer side of the arm. The forearm muscles are thinner than those of the upper arm and do not bunch when flexed to the extent that the biceps and triceps do.

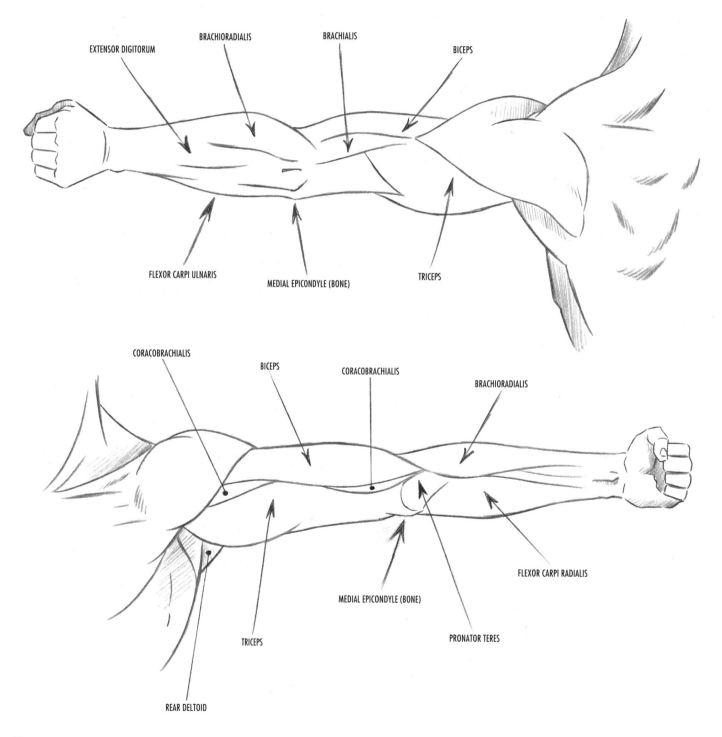

EXTENSOR DIGITORUM

BRACHIORADIALIS

BRACHIALIS

BICEPS

FLEXOR CARPI ULNARIS

MEDIAL EPICONDYLE (BONE)

TRICEPS

CORACOBRACHIALIS

BICEPS

CORACOBRACHIALIS

BRACHIORADIALIS

FLEXOR CARPI RADIALIS

MEDIAL EPICONDYLE (BONE)

PRONATOR TERES

TRICEPS

REAR DELTOID

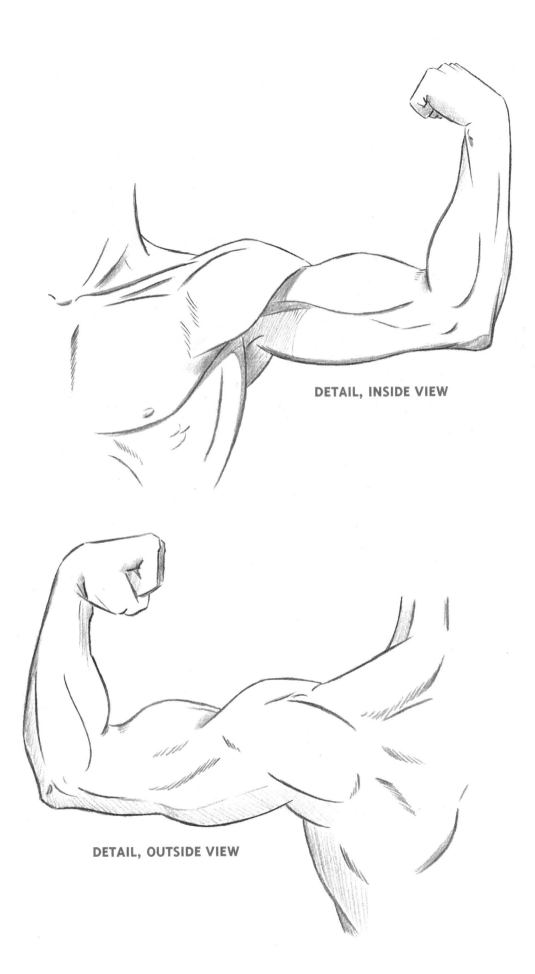

**DETAIL, INSIDE VIEW**

**DETAIL, OUTSIDE VIEW**

# "THE SHOW-THROUGH" BONES OF THE ARM

Arm muscles, being the more actively used muscles of the body, are often well developed.

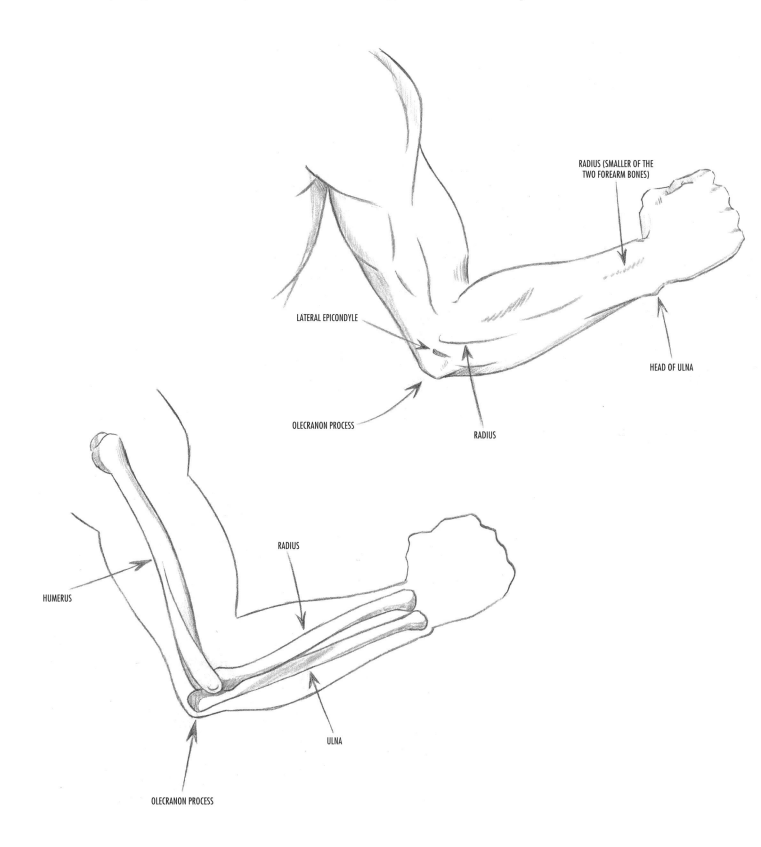

RADIUS (SMALLER OF THE TWO FOREARM BONES)

LATERAL EPICONDYLE

HEAD OF ULNA

OLECRANON PROCESS

RADIUS

RADIUS

HUMERUS

ULNA

OLECRANON PROCESS

*Lateral epicondyle, which protrudes slightly from the inside of the elbow joint*

# THE FOREARM

The forearm has a unique ability, when rotated, to twist its two bones that were previously parallel to each other so that one (the radius) overlaps the other (the ulna). The twisting motion of the bone tugs some of the forearm muscles with it in a corkscrew fashion, as demonstrated:

## SUPINATED POSITION
Supination means the palm is facing forward or upward. In this position, both bones in the forearm are parallel to each other. The muscles flow into ligaments as they approach the hand.

LIGAMENTS

## PRONATED POSITION
Pronation means the palm is facing downward or backward. By rotating the forearm, the radius, which is the shorter of the two bones, crosses over the ulna. Remember, the ulna is the bone that gives the elbow its familiar protruding joint, as well as the familiar protruding wrist bone. Notice the flow of the muscles.

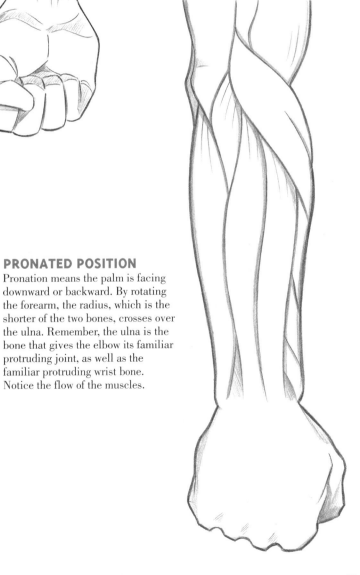

# UNDER THE ARM

When the arm is raised, the muscle known as the teres major is apparent. It can be confusing, because at first glance, it appears to be the shoulder muscle. In fact, it is the teres major muscle, wrapping around from the shoulder blade, up and under the arm.

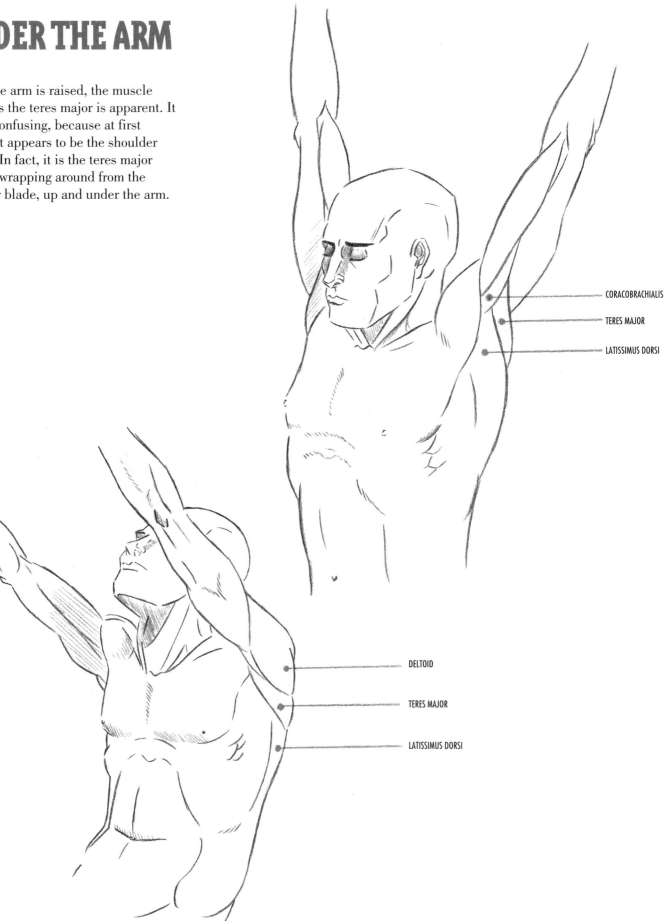

CORACOBRACHIALIS

TERES MAJOR

LATISSIMUS DORSI

DELTOID

TERES MAJOR

LATISSIMUS DORSI

# THE SHOULDER

The shoulder muscle, known as the deltoid, is actually made up of three parts: back, middle, and front. They are not always visibly defined, except on athletic types, and when the arm sustains a certain position. For example, when the arm is raised above shoulder level, the three heads of the deltoid are more easily differentiated.

*The shoulder is still visible from the side in this position.*

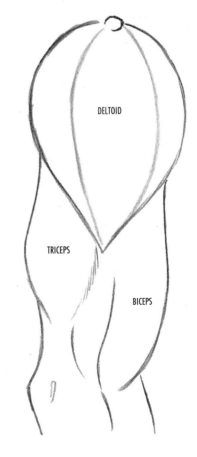

DELTOID

TRICEPS

BICEPS

# THE SHOULDER BLADE (SCAPULA)

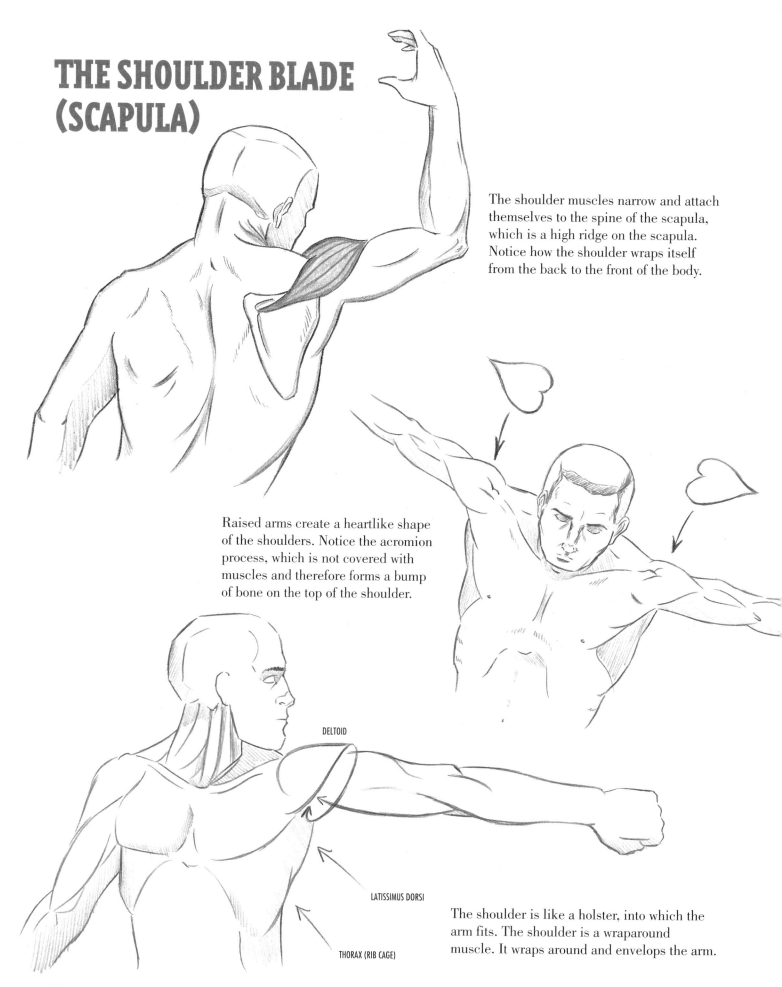

The shoulder muscles narrow and attach themselves to the spine of the scapula, which is a high ridge on the scapula. Notice how the shoulder wraps itself from the back to the front of the body.

Raised arms create a heartlike shape of the shoulders. Notice the acromion process, which is not covered with muscles and therefore forms a bump of bone on the top of the shoulder.

DELTOID

LATISSIMUS DORSI

THORAX (RIB CAGE)

The shoulder is like a holster, into which the arm fits. The shoulder is a wraparound muscle. It wraps around and envelops the arm.

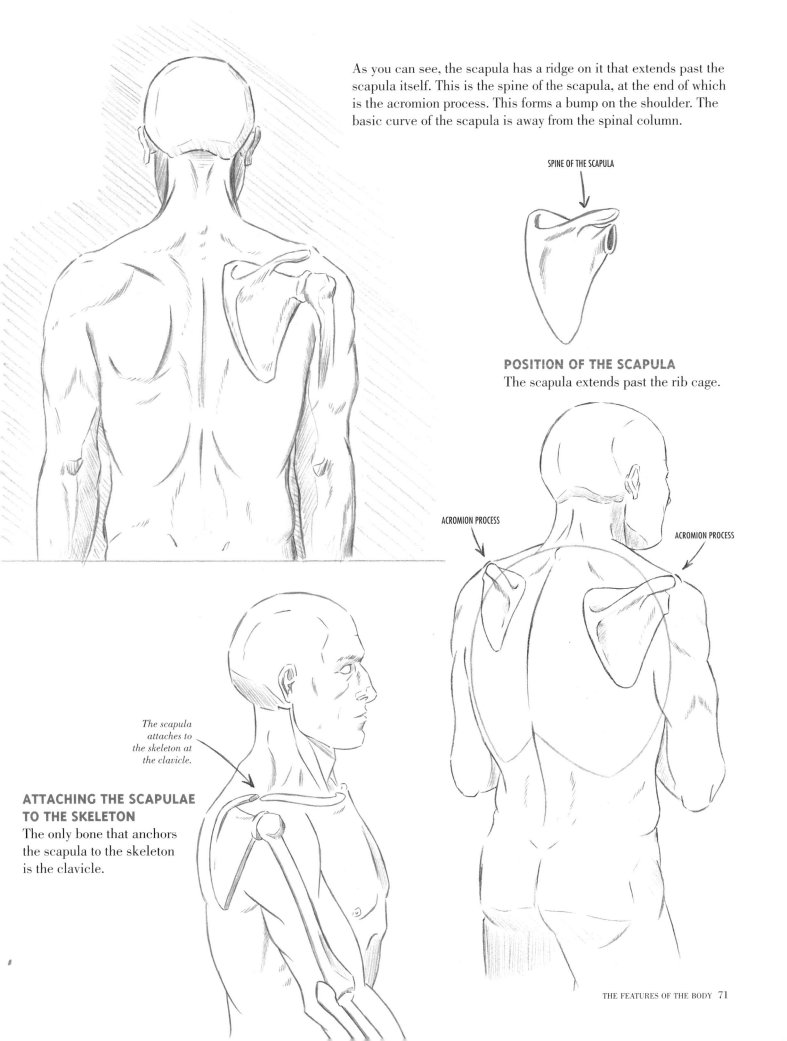

As you can see, the scapula has a ridge on it that extends past the scapula itself. This is the spine of the scapula, at the end of which is the acromion process. This forms a bump on the shoulder. The basic curve of the scapula is away from the spinal column.

SPINE OF THE SCAPULA

## POSITION OF THE SCAPULA
The scapula extends past the rib cage.

ACROMION PROCESS

ACROMION PROCESS

*The scapula attaches to the skeleton at the clavicle.*

## ATTACHING THE SCAPULAE TO THE SKELETON
The only bone that anchors the scapula to the skeleton is the clavicle.

# THE MOVEABLE SHOULDER BLADES (SCAPULAE)

The scapulae are not fixed in a single position on the back, and as a result, they can move with the arm across a wide section.

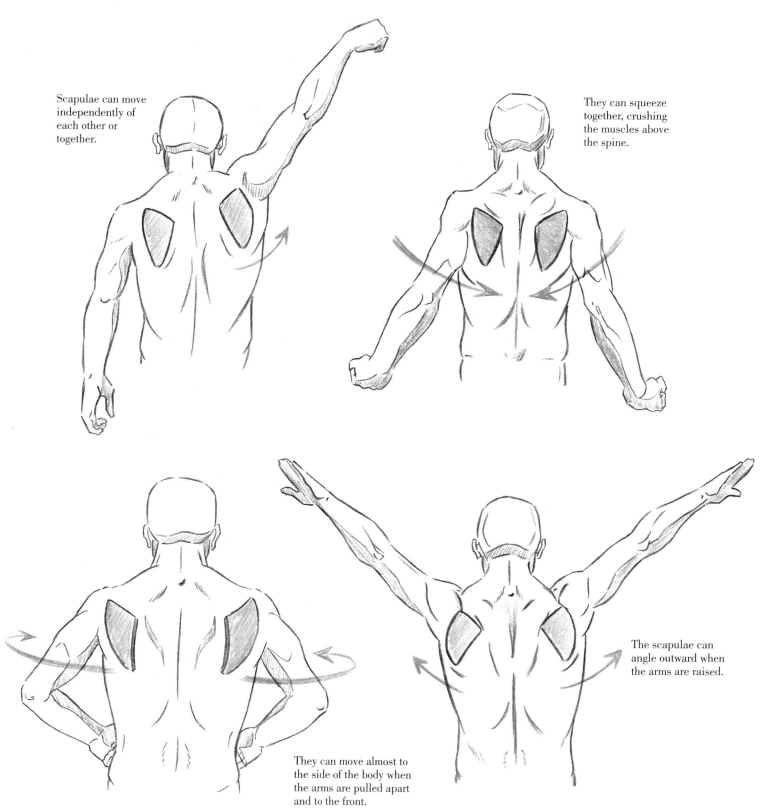

Scapulae can move independently of each other or together.

They can squeeze together, crushing the muscles above the spine.

They can move almost to the side of the body when the arms are pulled apart and to the front.

The scapulae can angle outward when the arms are raised.

# THE BACK, WITHOUT MUSCLES

The back is a combination of many muscles. Let's view the major ones, as we build up the back, one muscle group at a time. To begin, let's look at the skeletal structure.. Leaving out the rib cage so as to avoid cluttering the drawing, let's take a look at the skeletal landmarks of the back. We are concerned with the seventh vertebra of the spine, which separates the neck from the back and protrudes, as well as the scapulae, and the pelvis, which is located at the base of the spine.

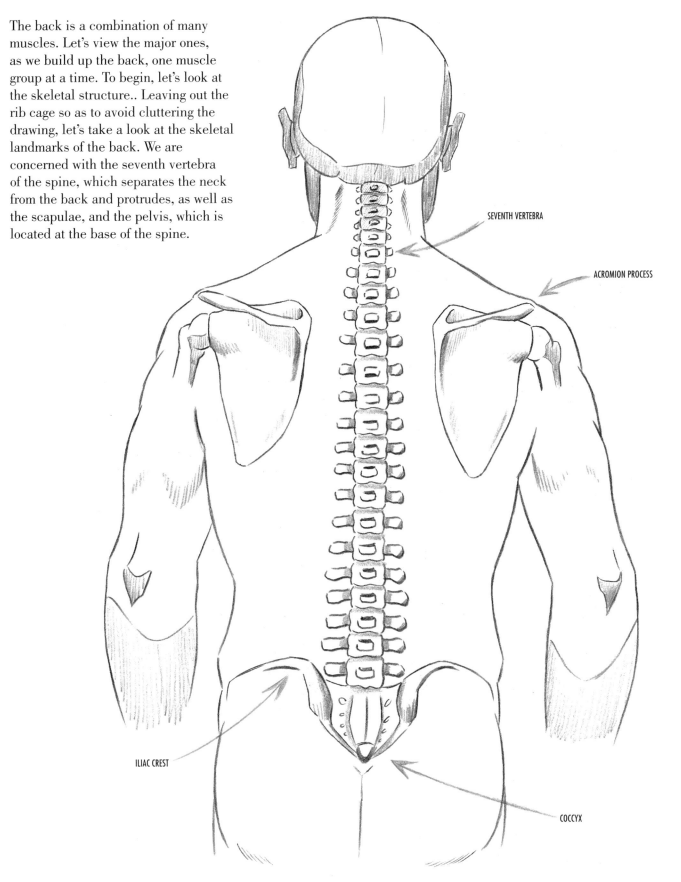

SEVENTH VERTEBRA

ACROMION PROCESS

ILIAC CREST

COCCYX

# THE MAJOR MUSCLES OF THE BACK

We'll add the top half of the long trapezius, which flows without a break from the base of the skull down the middle of the back. Then we'll add the latissimus dorsi, the largest muscles of the middle back.

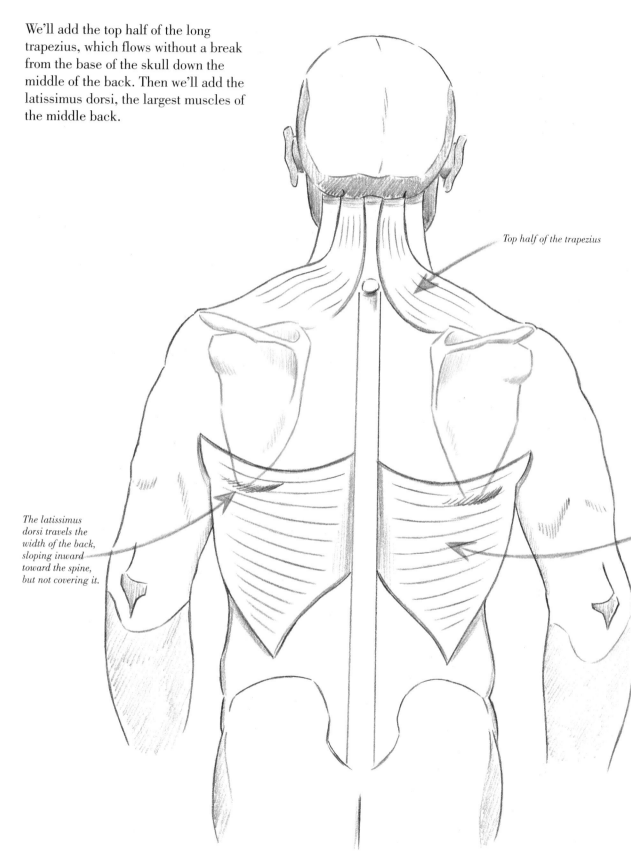

*Top half of the trapezius*

*Note that the latissimus dorsi overlaps the bottom of the scapula, creating a noticeable demarcation at the back.*

*The latissimus dorsi travels the width of the back, sloping inward toward the spine, but not covering it.*

# FILLING OUT THE MUSCLES OF THE BACK

Now lets add the bottom half of the trapezius. Note that the area surrounding the seventh vertebra is a depression in the muscles. The scapulae also have several important muscles attached to them. A word of caution, however: Unless the figure you are drawing is of a well-developed athlete, it is best to leave out most of the muscles of the scapulae. With their reduced muscle size, this holds especially true for women. Instead, indicate the partial outline of the scapula itself, as well as the musculature of the latissimus dorsi, the part where it overlaps the bottom of the scapula.

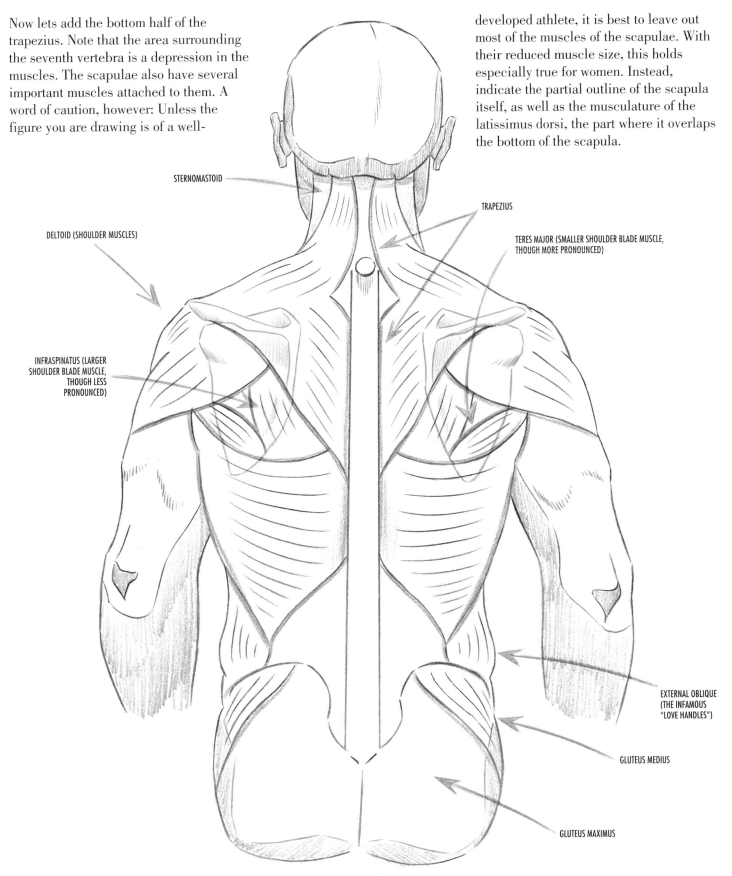

STERNOMASTOID

TRAPEZIUS

DELTOID (SHOULDER MUSCLES)

TERES MAJOR (SMALLER SHOULDER BLADE MUSCLE, THOUGH MORE PRONOUNCED)

INFRASPINATUS (LARGER SHOULDER BLADE MUSCLE, THOUGH LESS PRONOUNCED)

EXTERNAL OBLIQUE (THE INFAMOUS "LOVE HANDLES")

GLUTEUS MEDIUS

GLUTEUS MAXIMUS

# SURFACE MUSCLES OF THE BACK:
# The Athlete

These are the muscles of the back as
they appear on a well-defined person.
Note how the deltoids tend to encroach
on the area of the back. The muscles
that cover the scapula are not too
complicated, but you need to
understand the underlying anatomy.
The latissimus dorsi are the largest
muscles on the back. Note how the
spinal column is at least partially
visible all the way up and down the
back. There is a pocket of shallowness
near the seventh vertebra, which
begins the neck.

# SURFACE ANATOMY OF THE BACK: The Average Person

Not all people will have such developed muscles in the back. But even on bodies that are not well-defined, it is important to indicate where the lower latissimus dorsi muscles end, which is just above the small of the back. Also give some indication to the spinal column, especially near the seventh vertebra. It's not necessary to draw all of the muscles covering the shoulder blades. Simply draw an indication of the spine of the scapula. (For clarification, please refer to the illustrations on page 66.)

# THE CHEST AND RIB CAGE

**DIRECTION OF THE CHEST MUSCLES**
The chest muscles spread out from the sternum and travel horizontally around the chest toward the armpits.

**ARMS RAISED**
In this diagram you can see how the chest muscles join the shoulder muscles. Also notice that by lifting the arms, the outer region of the man's chest muscles lifts upward, which in turn lessens the definition of the chest muscles.

Draw the
first row
completely.

Draw the
second row
completely.

## THE MUSCLES COVERING
## THE RIB CAGE

These muscles are called the
serratus anterior. Typically, the
ribs themselves show, but if the
subject is athletic or powerful,
these muscles are defined and
should be shown. The serratus
anterior are two columns of
muscles that fit snugly into
one another, as shown.

# THIN SUBJECTS

On women and average men, it usually suffices to simply sketch in a partial indication of ribs on either side of the rib cage. By expanding her chest and holding her breath, this subject reveals a well-defined rib cage.

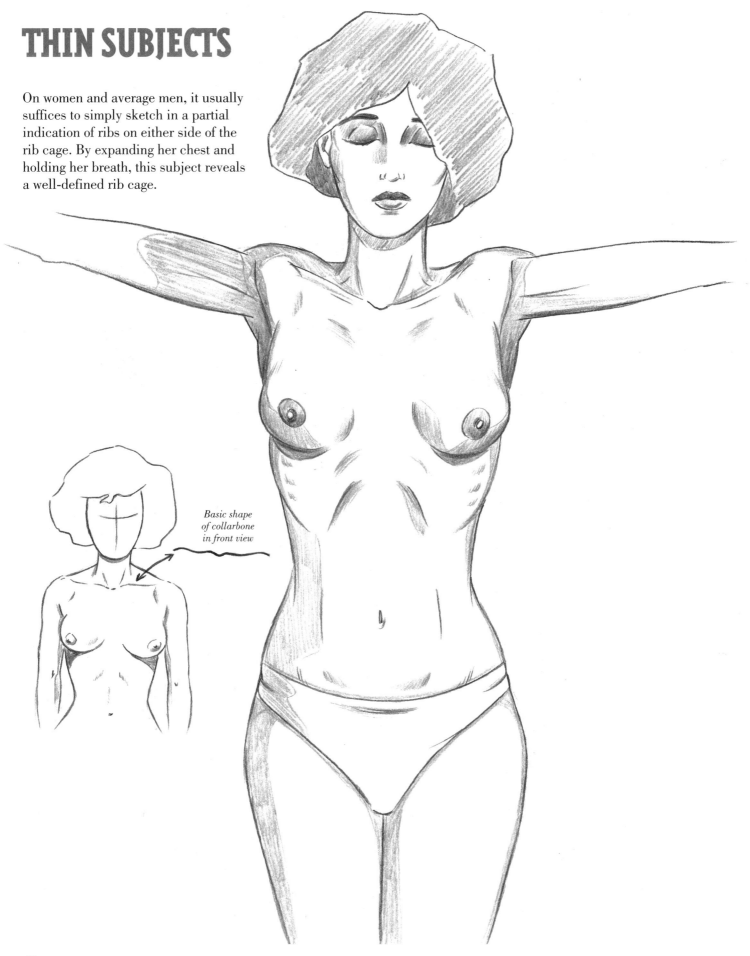

*Basic shape of collarbone in front view*

# THE MAJOR MUSCLES OF THE LEG: Front View

The leg muscles are long and generally not as well-defined as the arms, except in athletic types. But the leg muscles are responsible for giving the overall leg its curved shape.

The muscle that's highlighted in red is the sartorius, the longest muscle in the body. It's what gives the inner thigh the sweeping curve from the inner knee to the hip. The calf is not completely covered with muscle. Some of the shinbone is exposed. This is what makes it so sensitive to injury.

TENSOR
FASCIAE
LATAE

TENSOR
FASCIAE

SARTORIUS

VASTUS
LATERALUS

RECTUS
FEMORIS

VASTUS
MEDIALUS

*Outer leg*

*Bumps out
further here*

*More
fat here*

*Inner leg*

GASTROCNEMIUS

PERONEUS LONGUS

*Less
pronounced
calf muscles*

SOLEUS

# THE MAJOR MUSCLES OF THE LEG: Side View

Notice how the thigh is rounded on both sides, not straight. The calf also bulges, but the shinbone is more or less straight, although it does have a subtle sweep toward the toes. Note the fat deposit above the knee, caused by the locked-knee position. The head of the fibula is visible just below the knee.

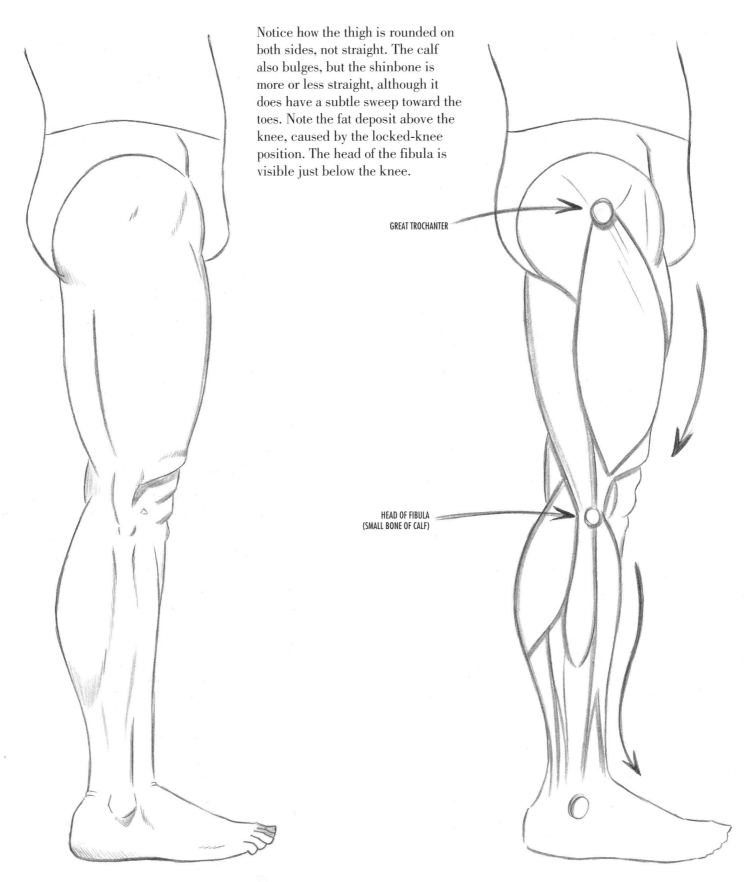

GREAT TROCHANTER

HEAD OF FIBULA
(SMALL BONE OF CALF)

# THE MAJOR MUSCLES OF THE LEG: Back View

Note how the tendons of the lower leg extend from the calf muscles to the heel. Tendons are attached to muscles, while ligaments are attached to bones. Note that there are two major muscles of the calf, the lateral and medial head of the gastrocnemius.

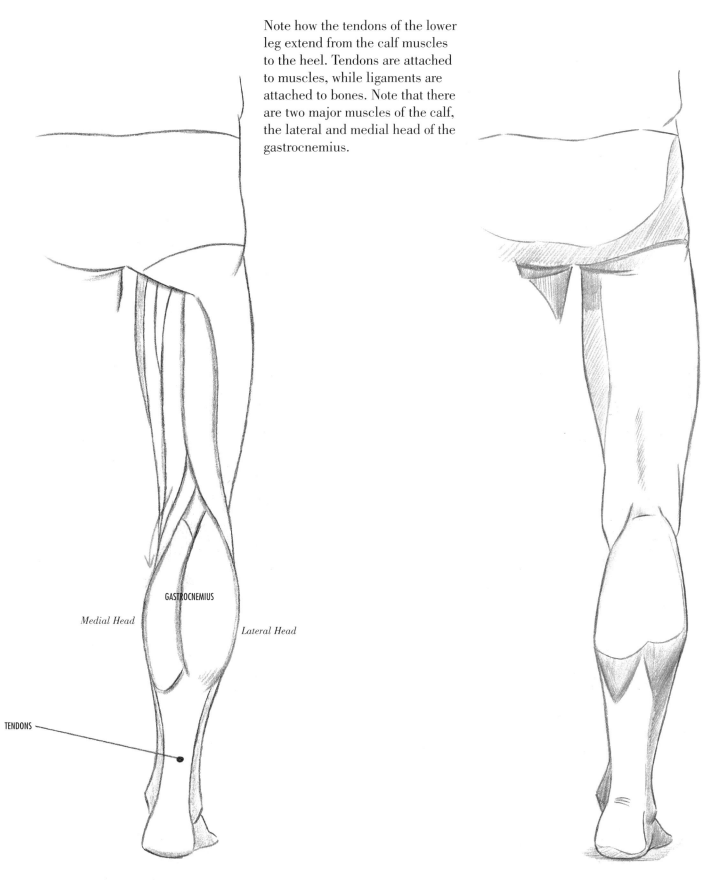

GASTROCNEMIUS

*Medial Head*

*Lateral Head*

TENDONS

# LINES OF COMPRESSION

When a limb bends sharply, the compression of muscles at the joint creates a contour line that curves in one direction, and then curves back in the opposite direction, like an "S".

**EXTENSOR CARPI RADIALIS BREVIS**

## COMPRESSION LINES
Note how each line curves in two directions, like an "S".

## BENT ARM
Note the curving compression line. In addition, a smaller line indicates the compression of the short extensor of the forearm (extensor carpi radialis brevis). The extensor muscles straighten the palm and open the fingers.

**VASTUS MEDIALIS**

## BENT LEG
In this position the compression line takes the form of the calf, not that of the upper leg. Note the smaller compression above the knee of the vastus medialis, one of the four muscles of the quadriceps group.

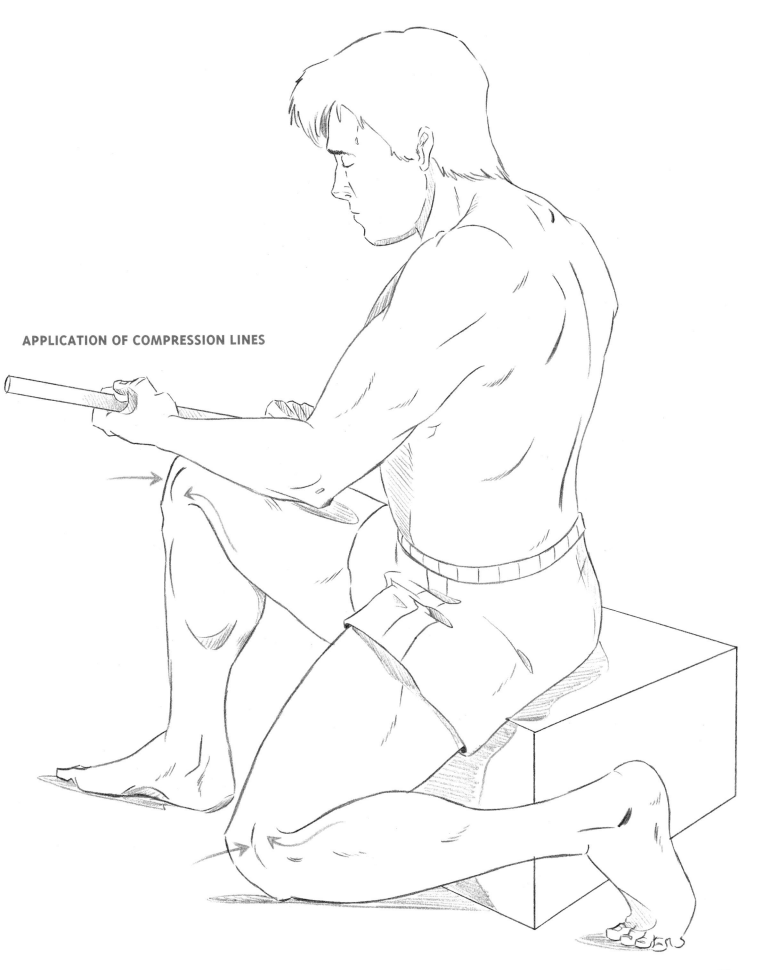

**APPLICATION OF COMPRESSION LINES**

# THE KNEE

To draw the knee, all you need to do is look at the skeleton. It's that simple. The knee joint is a combination of the joint of the femur, tibia, patella, and protrusions of bone just below and on the outer side of the knee.

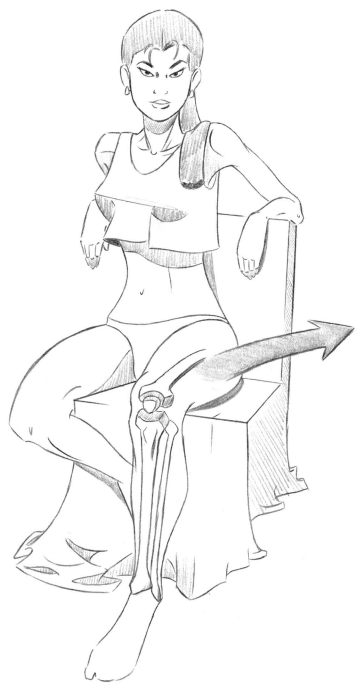

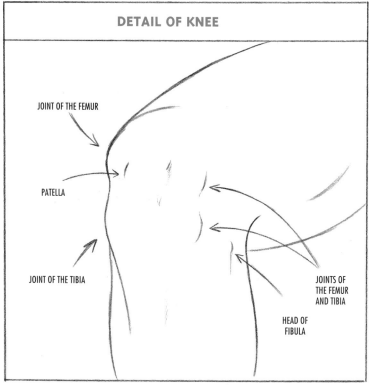

**DETAIL OF KNEE**

JOINT OF THE FEMUR

PATELLA

JOINT OF THE TIBIA

JOINTS OF THE FEMUR AND TIBIA

HEAD OF FIBULA

# DRAWING THE KNEE, VARIATIONS

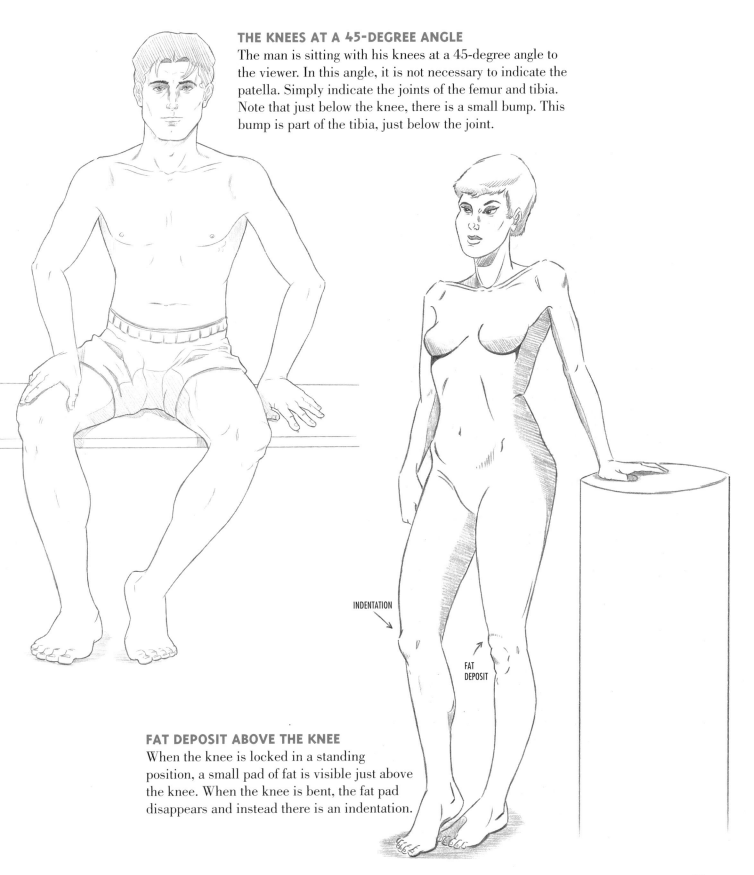

## THE KNEES AT A 45-DEGREE ANGLE
The man is sitting with his knees at a 45-degree angle to the viewer. In this angle, it is not necessary to indicate the patella. Simply indicate the joints of the femur and tibia. Note that just below the knee, there is a small bump. This bump is part of the tibia, just below the joint.

INDENTATION

FAT DEPOSIT

## FAT DEPOSIT ABOVE THE KNEE
When the knee is locked in a standing position, a small pad of fat is visible just above the knee. When the knee is bent, the fat pad disappears and instead there is an indentation.

# THE HAND

Take special care, because drawing hands incorrectly will surely attract unwanted attention. There are many things that you intuitively know about your own hand, which you must bring to the fore of your consciousness when drawing it. For example, you know that your middle finger is the longest, followed by your ring finger, index finger, and pinkie. This, naturally, must be indicated, as well as the knuckles and joints that stick out.

Notice the fingertips. They are like tiny pads, rounder and softer than the rest of the fingers. Notice how weak and small the pinkie finger is in comparison to the other four. Observe the major lines that crisscross the palm, the creases between finger joints, and the backward curve of the thumb.

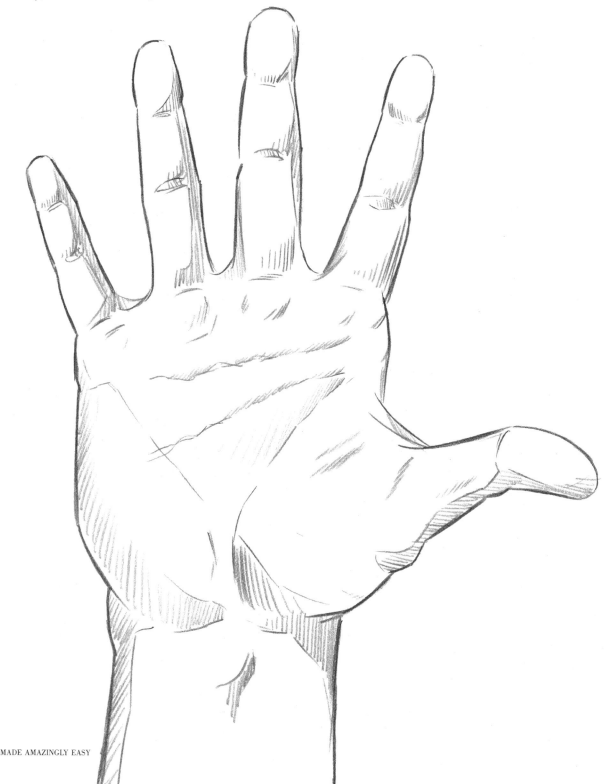

# THE BACK OF THE HAND

### THE BONES
Notice that the hand is made up of a large number of bones and joints, that even the palm itself is basically an extension of the fingers, and that the bony base of the hand is quite small.

WRONG

RIGHT

### DETAIL OF FINGERS
The fingers are not straight as a board. As with the skeleton in general, the joints are the widest part of a bone.

INDEX FINGER TURNED
SLIGHTLY INWARD

BIT OF WEBBING

BIT OF WEBBING

### APPLICATION
The index finger is turned slightly inward. There is a bit of webbing between the fingers and thumb that is more pronounced when the hand is spread. And most importantly, remember that your thumb is made up of three bones, not two, and that it is only the last bone that gives the thumb its backward curve.

THUMB HAS THREE BONES
AND THREE JOINTS

# MORE HINTS FOR HANDS

## THE HAND, SIDE VIEW
Not all fingers will be visible in the side view. Notice that the top of the fingers is flat and the bottom of the fingers is shaped in curved sections.

*Note the bump formed by a wrinkle of skin.*

## THE FIST
The fist is marked by clenched fingers lined up in a descending scale. You may wonder: Why isn't the middle finger higher in the fist than the other fingers since it's the tallest one? The answer is that length has little to do with the height of the fingers in a clenched fist. What gives the fingers their height is the thumb muscle that is bunched beneath. The thumb muscle peaks next to the thumb, and as the fingers travel away from the thumb, the thumb muscle gets smaller and the fingers descend.

## THE FLEXIBLE HAND
The hand can bend and twist in many interesting ways. Make note of two things in this pose: The skin above the knuckles is loose and tends to wrinkle if compressed; and the second joint of the thumb is the most pronounced joint in the hand.

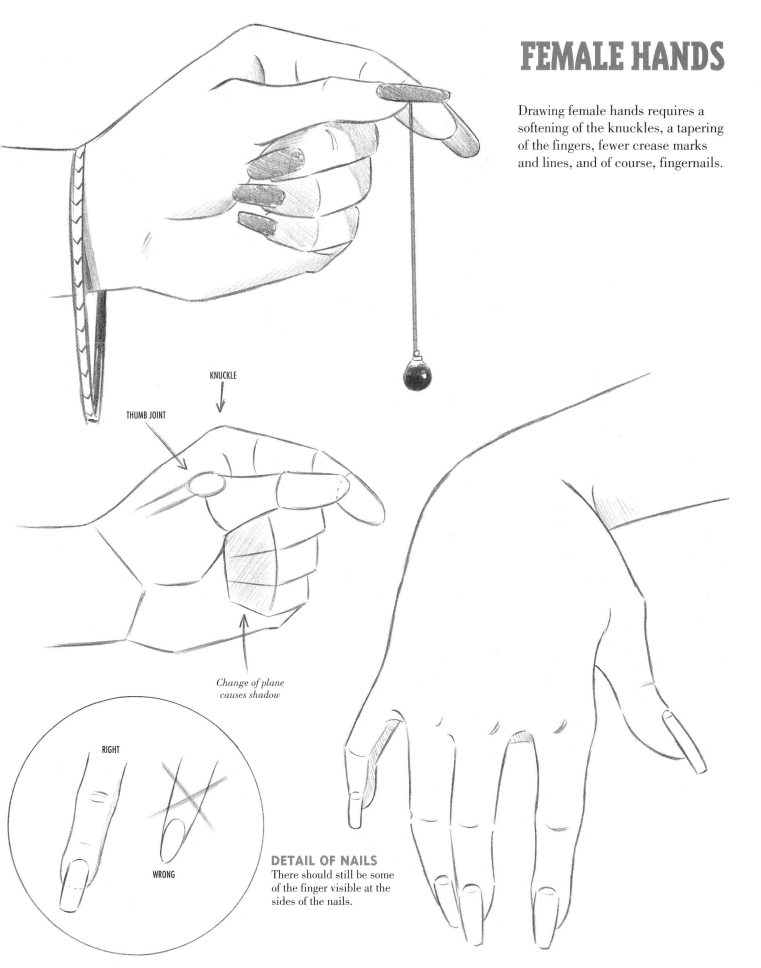

# FEMALE HANDS

Drawing female hands requires a softening of the knuckles, a tapering of the fingers, fewer crease marks and lines, and of course, fingernails.

KNUCKLE

THUMB JOINT

*Change of plane causes shadow*

RIGHT

WRONG

**DETAIL OF NAILS**
There should still be some of the finger visible at the sides of the nails.

# THE FEET

Luckily, the feet are fairly immobile, so once you understand the shape, you'll have it down. But the feet can appear quite different from different angles, so let's explore them.

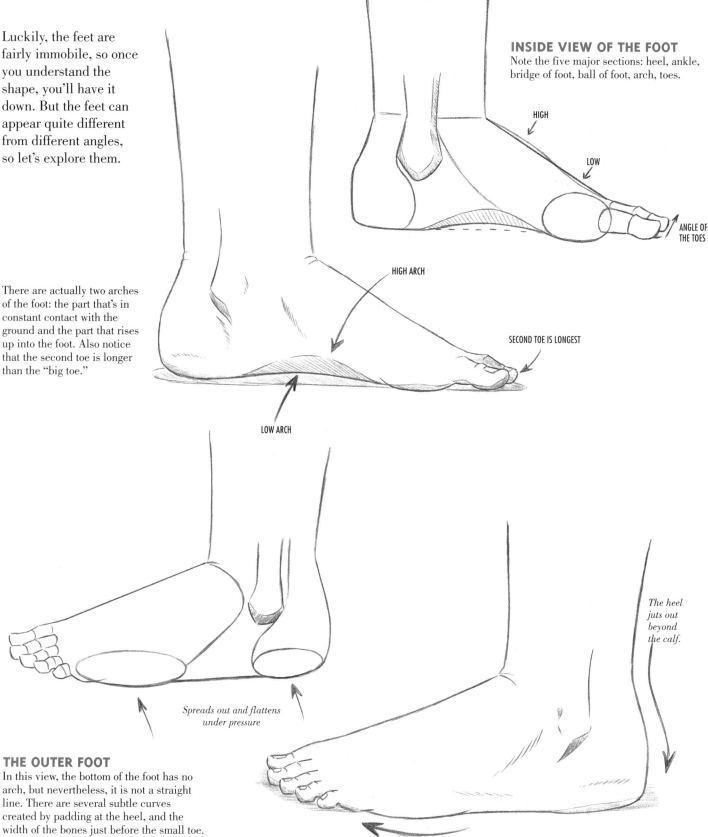

There are actually two arches of the foot: the part that's in constant contact with the ground and the part that rises up into the foot. Also notice that the second toe is longer than the "big toe."

**INSIDE VIEW OF THE FOOT**
Note the five major sections: heel, ankle, bridge of foot, ball of foot, arch, toes.

HIGH

LOW

ANGLE OF THE TOES

HIGH ARCH

SECOND TOE IS LONGEST

LOW ARCH

*Spreads out and flattens under pressure*

**THE OUTER FOOT**
In this view, the bottom of the foot has no arch, but nevertheless, it is not a straight line. There are several subtle curves created by padding at the heel, and the width of the bones just before the small toe.

*The heel juts out beyond the calf.*

*There is a subtle curve from the middle of the foot to the small toe.*

## FOOT GESTURE

In this pose, the bridge of the foot creates a hill, and slopes off to a valley just before the toes. Note how pronounced the heel becomes.

## THE JOINTS OF THE TOES

With the exception of the big toe, which has two joints, the other toes have three joints, creating three planes.

## ANKLE

Note the angle of the ankle: The outer ankle is farther back than the inner ankle.

## SOLE OF FOOT

In the relaxed position, the middle toe, which is the longest toe, appears to be shorter than the big toe, because it curls up more. Note the sharp angle made by the arch.

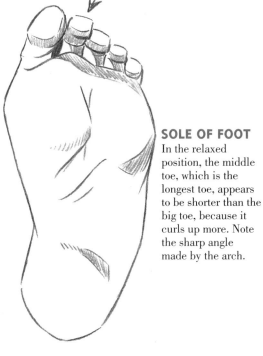

*There is a protrusion of bone on the side of the foot next to the big toe. . .*

*. . .and a smaller protrusion on the side of the foot next to the small toe.*

## DIRECTION OF THE TOES

The toes do not exactly face forward, even when the foot is positioned directly forward, as it is here. The toes point outward in slightly less than a 45-degree angle.

# THE DYNAMICS OF THE BODY

## ASYMMETRY

The body gains its graceful appearance in large part due to the asymmetry of the muscles. By asymmetry, I refer to groups of muscles that peak in different places. For example, the biceps crest further up the arm than the triceps. As a result, the arm muscles are not uniform, but rhythmic in appearance.

The asymmetry of this walking man is demonstrated by the dotted lines, which pass through the highest cresting points of a limb or muscle group.

**SYMMETRY**
The bulge on both sides peaks at exactly the same point. It is uniform and uninteresting.

**ASYMMETRY**
The bulge on both sides peaks at different points, creating a more interesting rhythm.

# ASYMMETRY OF THE UPPER ARM

The triceps peak higher up on the arm than do the biceps.

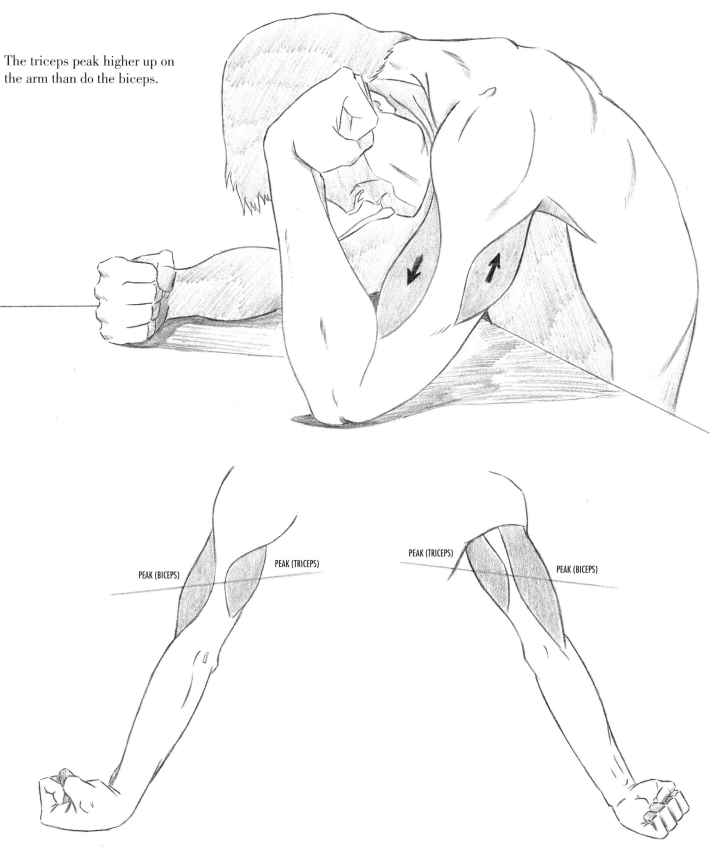

PEAK (BICEPS)

PEAK (TRICEPS)

PEAK (TRICEPS)

PEAK (BICEPS)

# ASYMMETRY OF THE TRICEPS

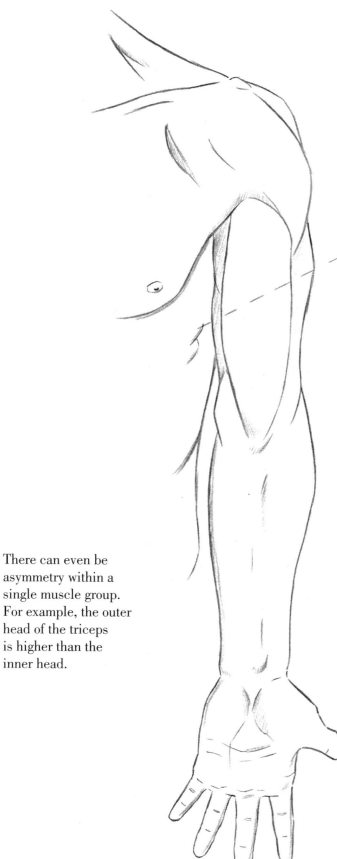

There can even be
asymmetry within a
single muscle group.
For example, the outer
head of the triceps
is higher than the
inner head.

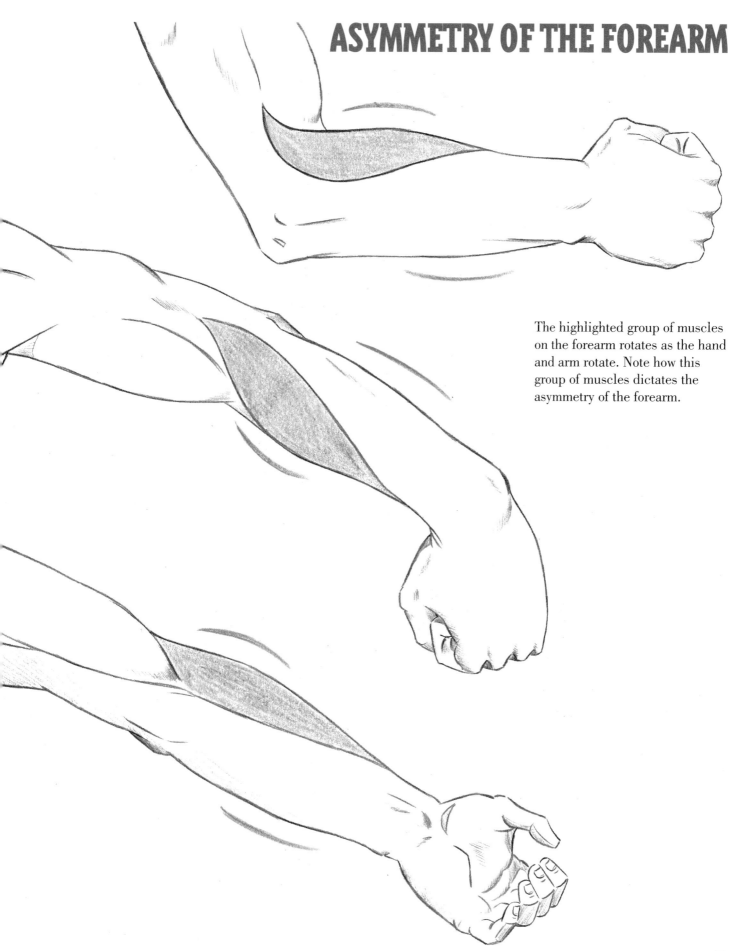

The highlighted group of muscles on the forearm rotates as the hand and arm rotate. Note how this group of muscles dictates the asymmetry of the forearm.

# ASYMMETRY OF THE KNEE AND CALF

The outer calf muscle peaks higher up than the inner calf muscle. The knee appears to peak higher on the front of the leg because the patella is attached to the femur.

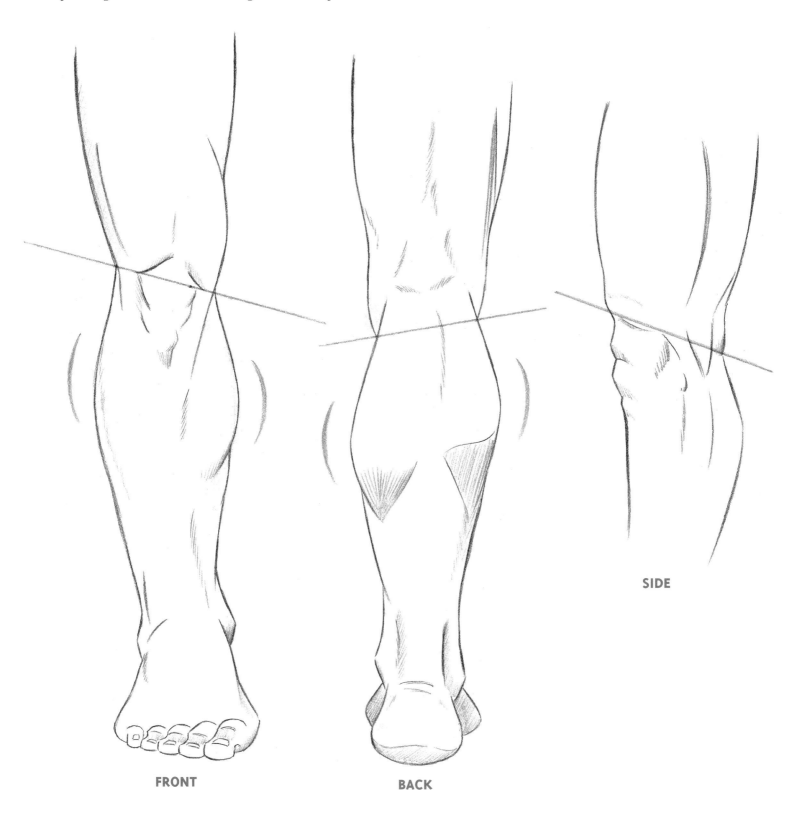

**FRONT**

**BACK**

**SIDE**

# ASYMMETRY OF THE ANKLE BONES

The inner ankle is always higher than the outer ankle, as demonstrated below.

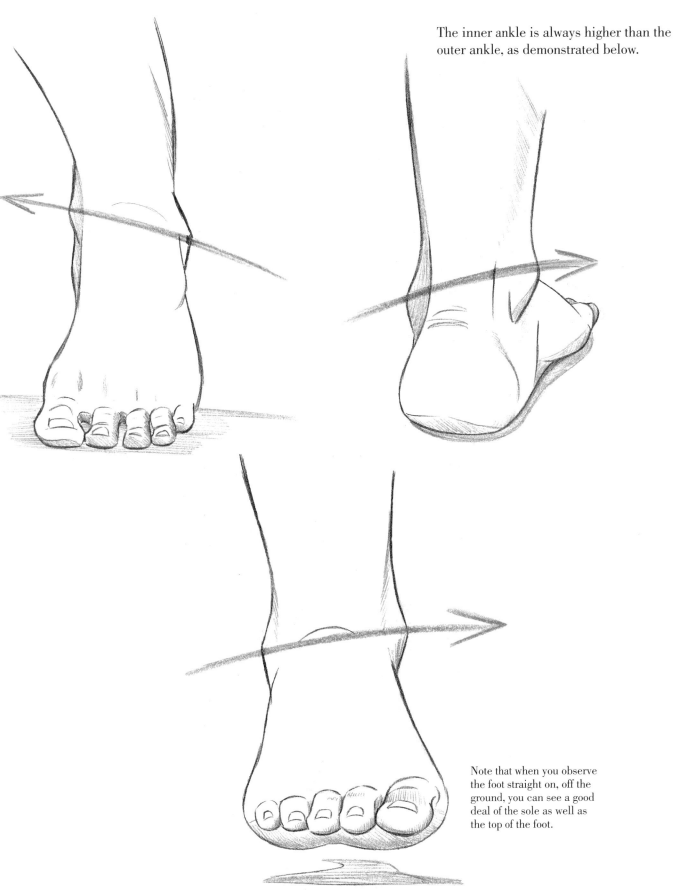

Note that when you observe the foot straight on, off the ground, you can see a good deal of the sole as well as the top of the foot.

# MUSCLES: Stretching and Flexing

When a limb flexes, the muscles on the side that bends in contract and bulge, while the muscles on the opposite side of the limb lengthen and stretch.

**ARM, STRAIGHTENED**
When the arm straightens, the triceps contract and bulge, while the biceps straighten and stretch.

**ARM, FLEXED**
When the arm bends, the biceps bulge while the triceps straighten and stretch.

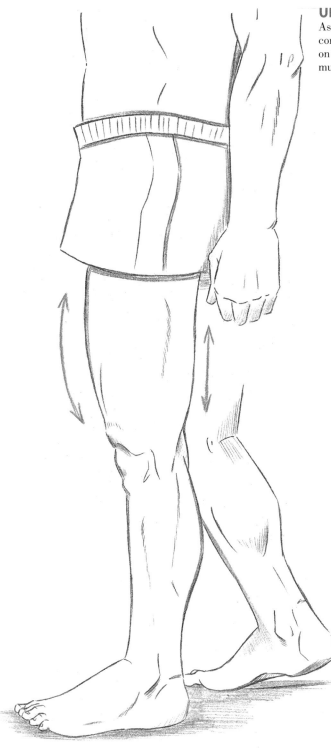

## UPPER LEG, STRAIGHTENED
As the leg locks, the front of the thigh contracts and bulges, while the muscles on the back of the leg, the hamstring muscles, lengthen and stretch.

## UPPER LEG, FLEXED
When the leg flexes, the leg biceps contract and bulge, while the front of the thigh lengthens and stretches.

# DIMINUTION

Diminution occurs when an object appears to be going away from you. The object becomes sharply diminished in size. The clearest example is a set of train tracks diminishing into the distance.

## DIMINUTION: THE ARM
An inexperienced artist might draw this standing woman with both bent arms of equal length, not recognizing that because she is turned at an angle to the viewer, the far arm must diminish in size, as the near arm lengthens in size.

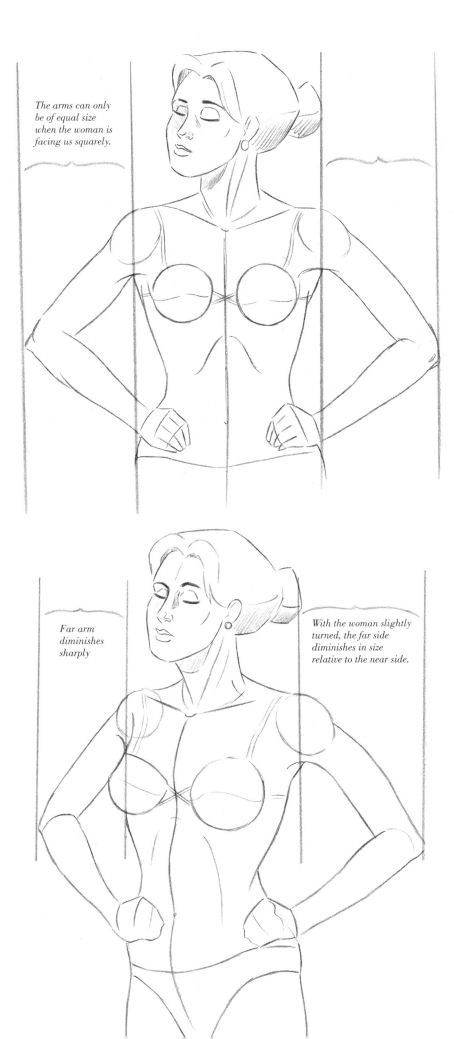

*The arms can only be of equal size when the woman is facing us squarely.*

*Far arm diminishes sharply*

*With the woman slightly turned, the far side diminishes in size relative to the near side.*

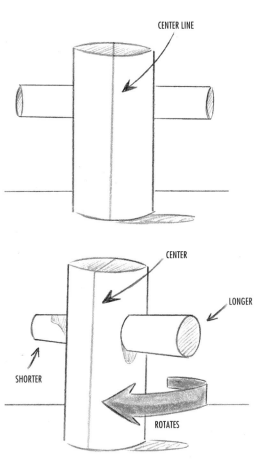

CENTER LINE

CENTER

LONGER

SHORTER

ROTATES

Here is an example of the mechanics of diminution.

Because of the severe angle of the far arm, it is drawn short. The only reason it doesn't look wrong is that the far arm diminishes sharply into the distance. Note how the subject's right hand overlaps the right forearm at the wrist and how the right forearm overlaps the right upper arm.

# FORESHORTENING

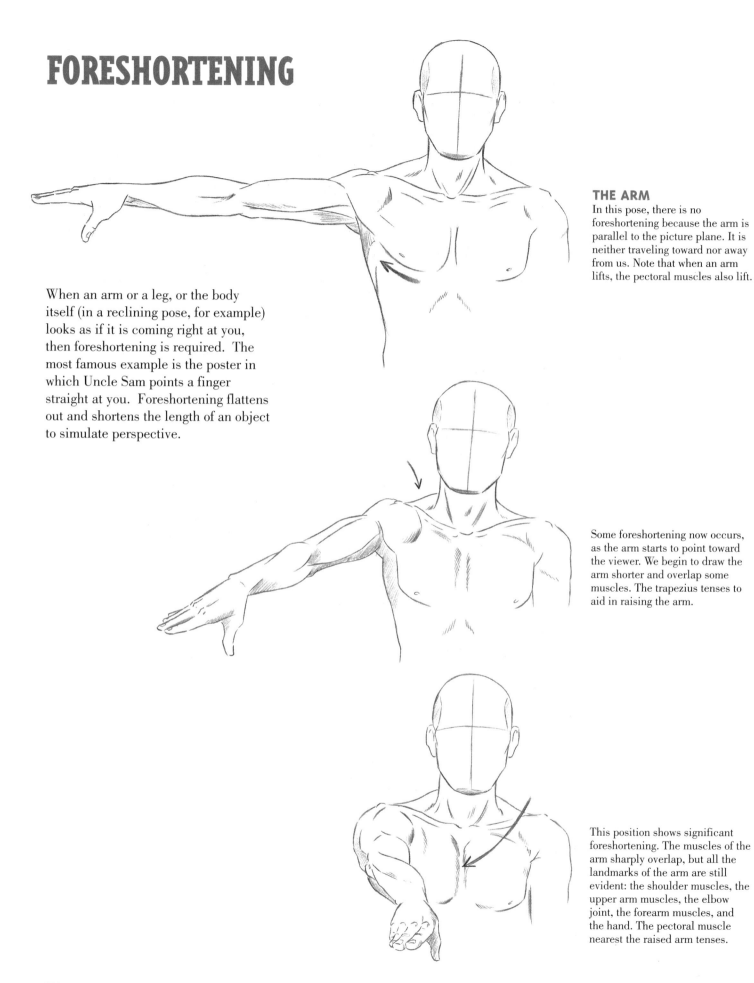

When an arm or a leg, or the body itself (in a reclining pose, for example) looks as if it is coming right at you, then foreshortening is required. The most famous example is the poster in which Uncle Sam points a finger straight at you. Foreshortening flattens out and shortens the length of an object to simulate perspective.

**THE ARM**
In this pose, there is no foreshortening because the arm is parallel to the picture plane. It is neither traveling toward nor away from us. Note that when an arm lifts, the pectoral muscles also lift.

Some foreshortening now occurs, as the arm starts to point toward the viewer. We begin to draw the arm shorter and overlap some muscles. The trapezius tenses to aid in raising the arm.

This position shows significant foreshortening. The muscles of the arm sharply overlap, but all the landmarks of the arm are still evident: the shoulder muscles, the upper arm muscles, the elbow joint, the forearm muscles, and the hand. The pectoral muscle nearest the raised arm tenses.

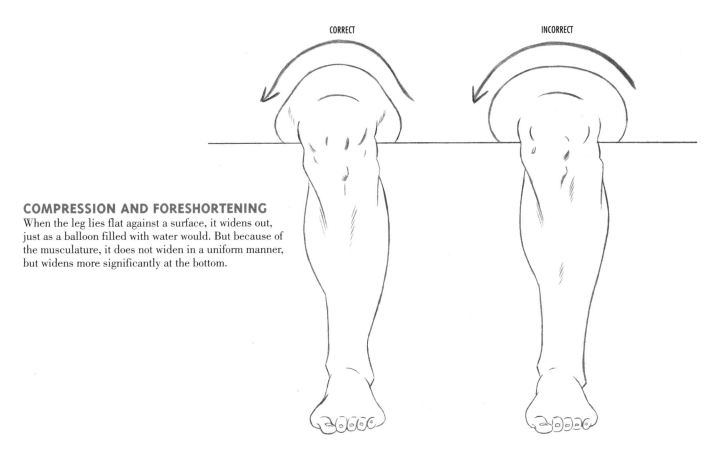

## FORESHORTENING: THE LEG
In perspective, the leg moves forward not in a circle, but in an oval. Note how the muscles surrounding the inner knee area overlap the upper and lower leg, to aid in the effect of foreshortening.

CORRECT

INCORRECT

## COMPRESSION AND FORESHORTENING
When the leg lies flat against a surface, it widens out, just as a balloon filled with water would. But because of the musculature, it does not widen in a uniform manner, but widens more significantly at the bottom.

# FORESHORTENING AND ELIMINATION

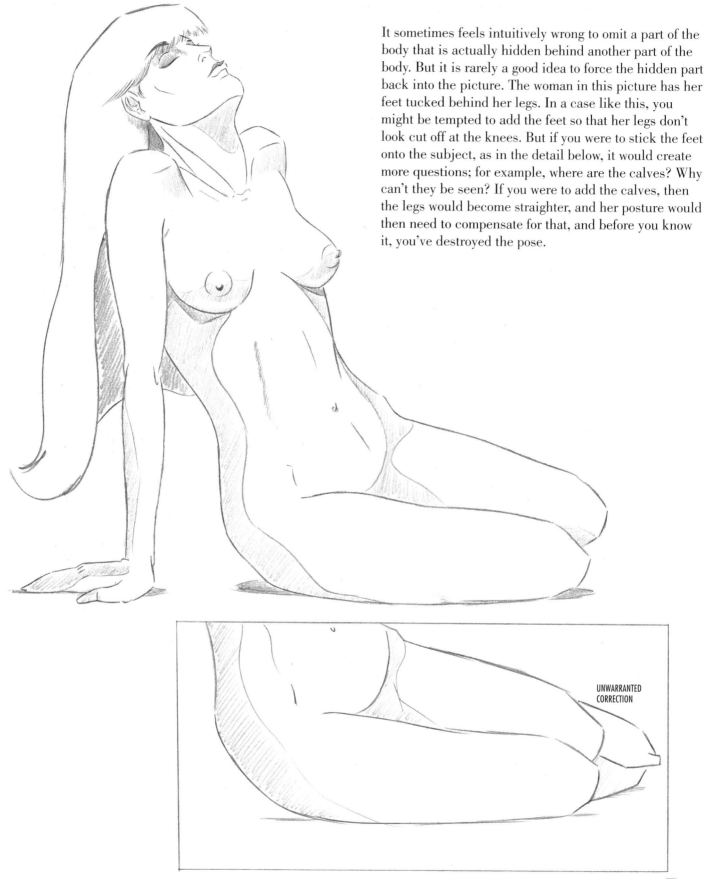

It sometimes feels intuitively wrong to omit a part of the body that is actually hidden behind another part of the body. But it is rarely a good idea to force the hidden part back into the picture. The woman in this picture has her feet tucked behind her legs. In a case like this, you might be tempted to add the feet so that her legs don't look cut off at the knees. But if you were to stick the feet onto the subject, as in the detail below, it would create more questions; for example, where are the calves? Why can't they be seen? If you were to add the calves, then the legs would become straighter, and her posture would then need to compensate for that, and before you know it, you've destroyed the pose.

UNWARRANTED CORRECTION

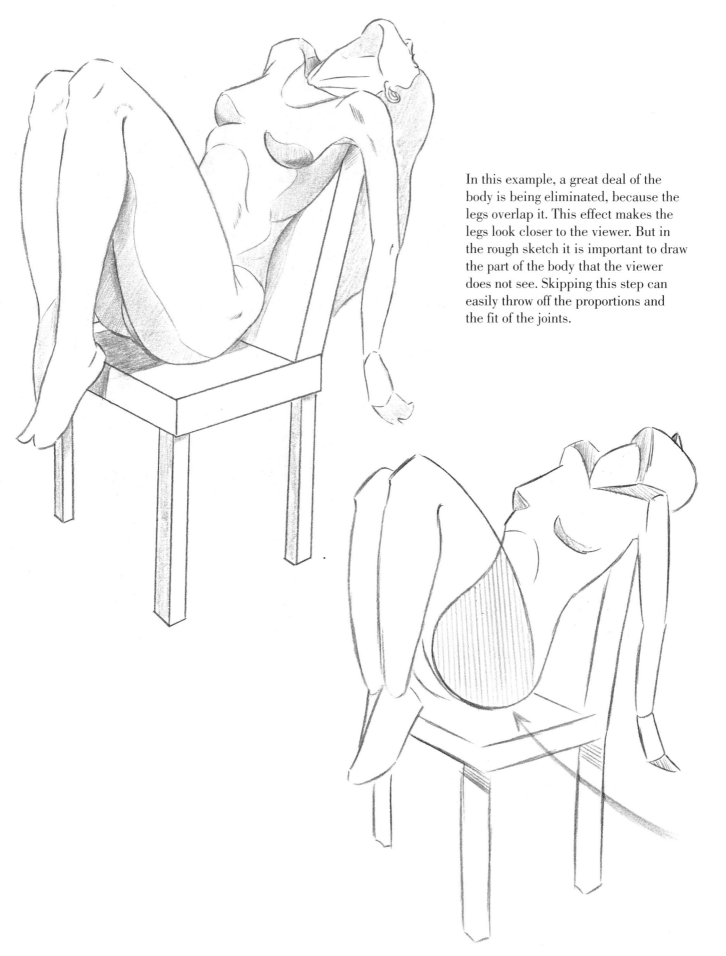

In this example, a great deal of the body is being eliminated, because the legs overlap it. This effect makes the legs look closer to the viewer. But in the rough sketch it is important to draw the part of the body that the viewer does not see. Skipping this step can easily throw off the proportions and the fit of the joints.

## DIMINISH EVERYTHING NOT PARALLEL TO THE PICTURE PLANE

Every limb in this drawing that is not traveling left to right across the picture plane, but is angled so that it appears to be traveling away from the viewer (see arrows), must diminish. The greater the angle at which the limb is traveling away from the viewer, the greater must be its diminution.

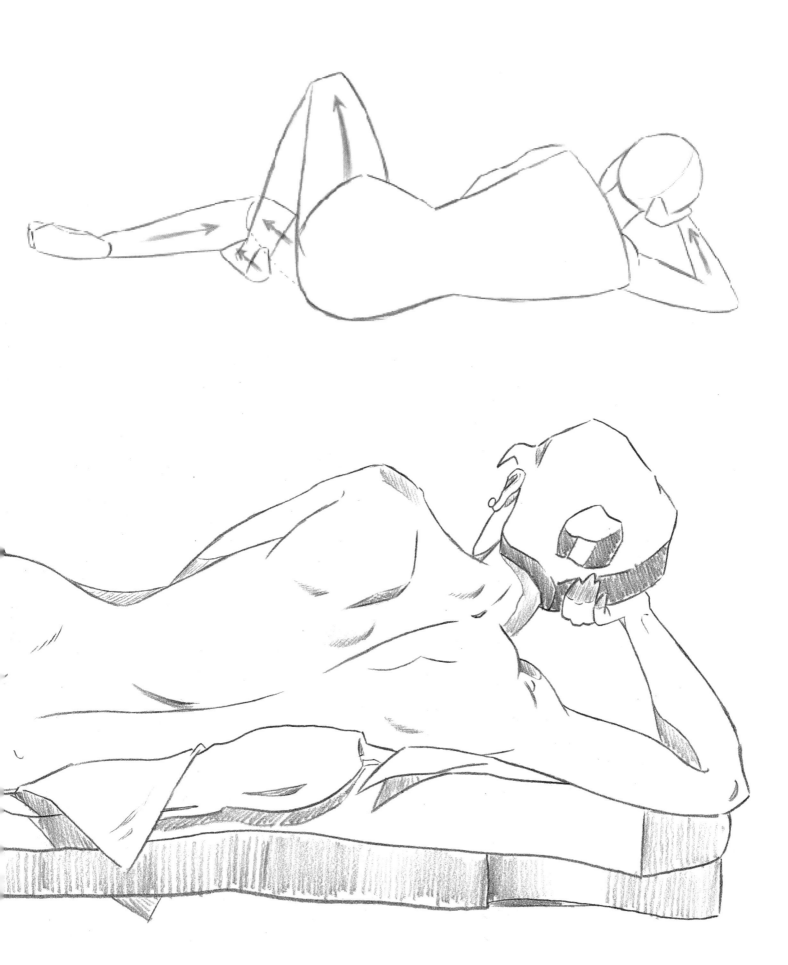

# SHIFTING WEIGHT AND BALANCE

Some people stand with their weight evenly placed on each foot. But the more common stance, especially for someone standing in the same spot for longer than thirty seconds, is to shift the majority of the weight onto one foot, thereby removing most of the weight from the other. When this happens, the body compensates in a way most pleasing to artists and illustrators. The body takes on dynamism. As one leg straightens to accommodate the added weight, the knee locks, pushing up the hip on the same side. To compensate for that hip rising, the shoulder on the same side dips, which in turn causes the arm on that side to lower. To compensate for the shoulder dipping, the head leans in the other direction, away from the weight-bearing side.

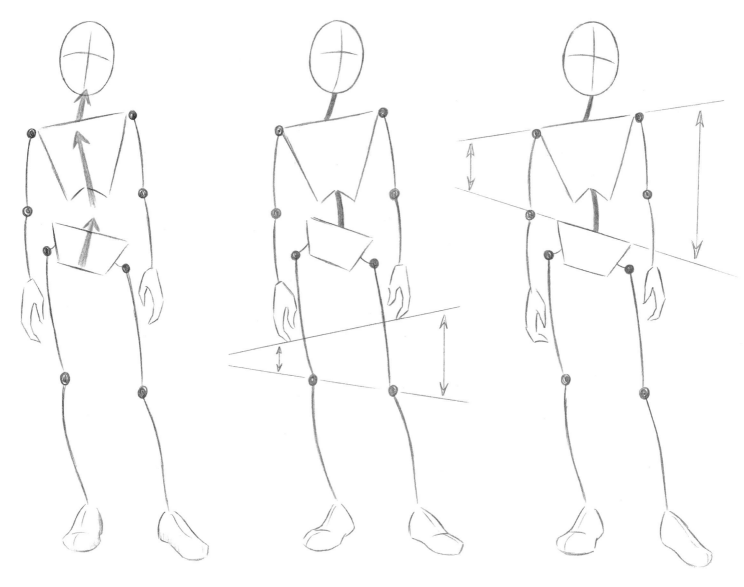

The weight is on the right leg. The locked leg pushes up the hip, causing the shoulder to dip and the arm on the same side to dip.

As a result of the compensation, the hand on the weight-bearing side is closer to the knee than is the other hand.

Note how one side of the body lengthens as the other side shortens.

# WHY DOES THE HIP SAG?

Think of the legs as two pillars holding up the hips. If one pillar breaks, the structure will sag on that side. As you lift up one leg to walk, the hip on that side sags, because of the same principle.

*As the knee bends, the hip sags on that side.*

*As the pillar collapses, the structure dips on that side.*

# THE WEIGHT-BEARING LEG

Here are more examples of standing poses with the majority of the weight on one foot. If you're having difficulty distinguishing which leg is the weight-bearing one, look to the hips for the answer. The higher hip is the weight-bearing leg.

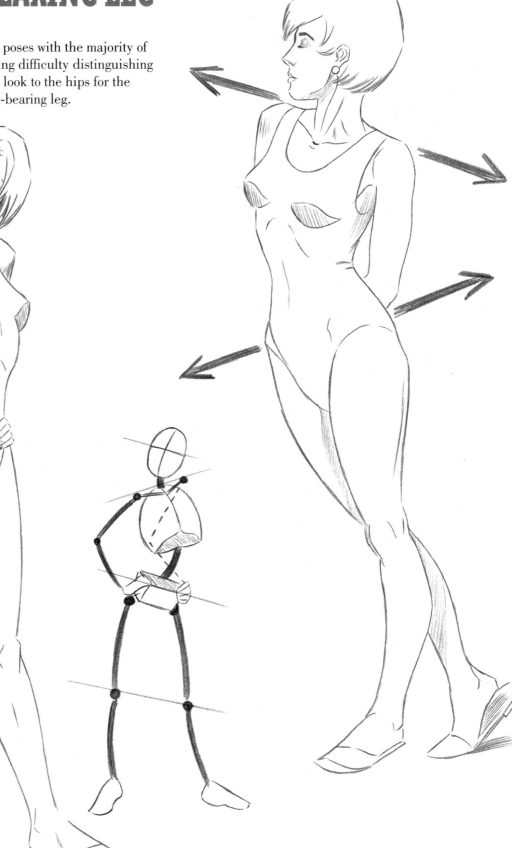

# MEASURING POINTS FOR WEIGHT-BEARING POSES

Where do you look to observe the slant of the hips? I find the most reliable method, in the front view, is to use the protruding bones just below the belt line as measuring points. You can find these bones (anterior superior illiac spine) on your own body. They are marked by the red "X" in the illustration.

In a back view, look for the high point of the hips, known quite aptly as the "high point of the pelvis."

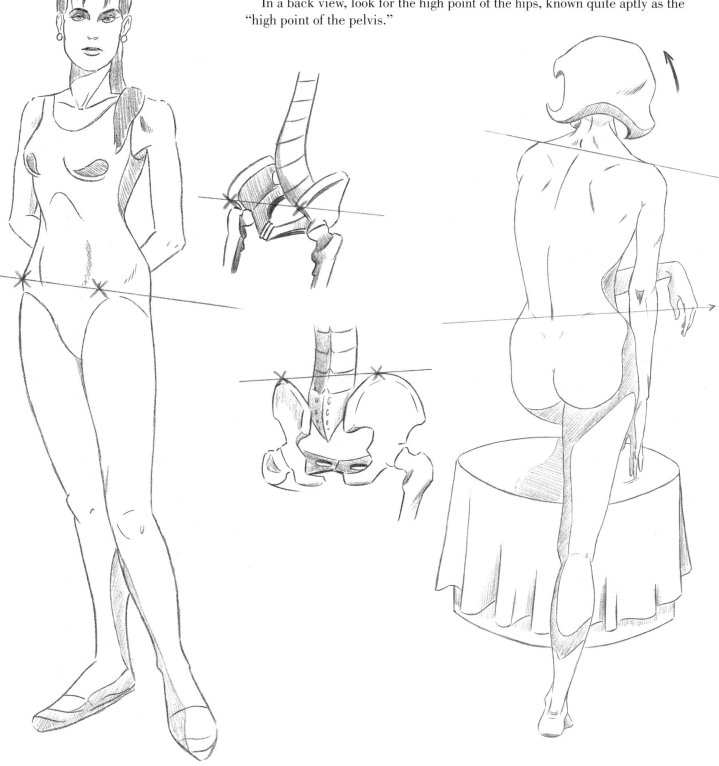

# THE MISLEADING KNEE

In the previous page, I recommended using the hips to find the weight-bearing leg. Why not the knee, you might ask. Shouldn't it be higher, as well? The answer is not necessarily.

Take a good look at this pose. The locked leg is bearing the majority of the weight, as is evidenced by the slant of the hips. The weight-bearing knee is actually lower than the more relaxed knee. By standing on the ball of her left foot, the model has added more height to the relaxed leg without shifting the weight onto it.

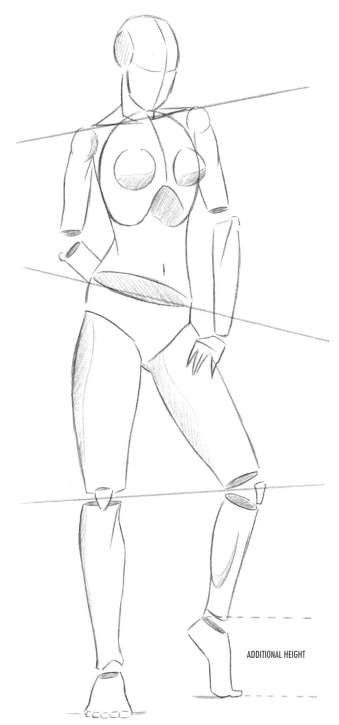

ADDITIONAL HEIGHT

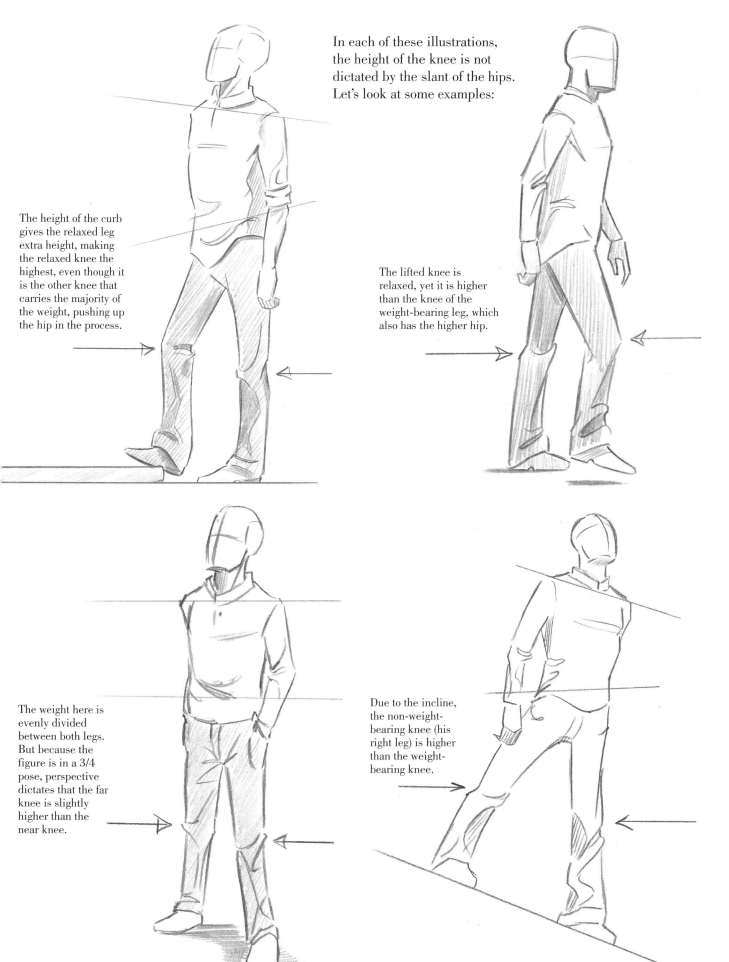

In each of these illustrations, the height of the knee is not dictated by the slant of the hips. Let's look at some examples:

The height of the curb gives the relaxed leg extra height, making the relaxed knee the highest, even though it is the other knee that carries the majority of the weight, pushing up the hip in the process.

The lifted knee is relaxed, yet it is higher than the knee of the weight-bearing leg, which also has the higher hip.

The weight here is evenly divided between both legs. But because the figure is in a 3/4 pose, perspective dictates that the far knee is slightly higher than the near knee.

Due to the incline, the non-weight-bearing knee (his right leg) is higher than the weight-bearing knee.

# DRAWING FROM A MODEL:
## The Use of Measuring Points

If you have never drawn from a model, I highly recommend it. Most art schools or liberal arts colleges offer life drawing classes.

The beginner can be overwhelmed by the complexity of drawing from a model. Our aim is to make it a manageable affair. One way to do this is to look for measuring points along the way, almost as a road map. For example, when drawing from a model in this pose, I first noticed that his shoulders and the top of his left hand are on the same level. The bottom of his waistband and the bottom of his right fist are also on the same level. And his two heels share yet another level. Use points like these to constrain your interpretation of the pose to reality.

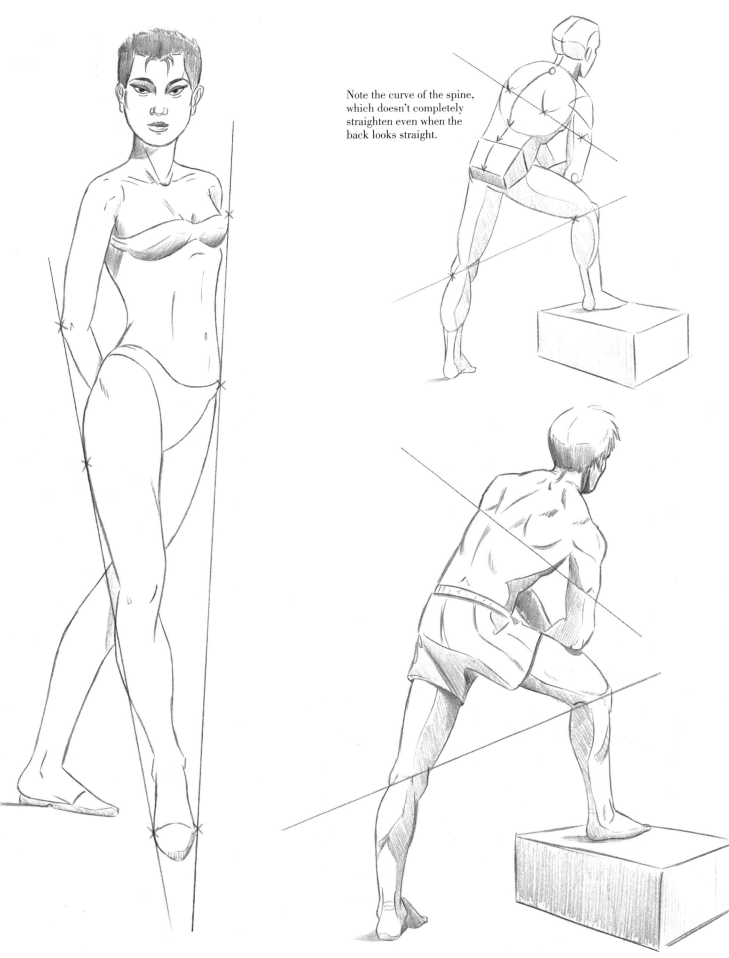

Note the curve of the spine, which doesn't completely straighten even when the back looks straight.

# NEGATIVE SPACE

Another way of measuring the model by sight is to observe the negative spaces created in a pose. Negative spaces are the empty shapes created within the outline of the pose. For example, look at the triangular shape of negative space under the model's raised leg. If you were drawing the model, and the negative space you drew resulted in a smaller area of negative space in comparison to what you observed on the model, you would know that you had erred.

You can also use negative spaces when drawing strictly from your imagination. Pleasing negative spaces within a pose tend to open up a drawing.

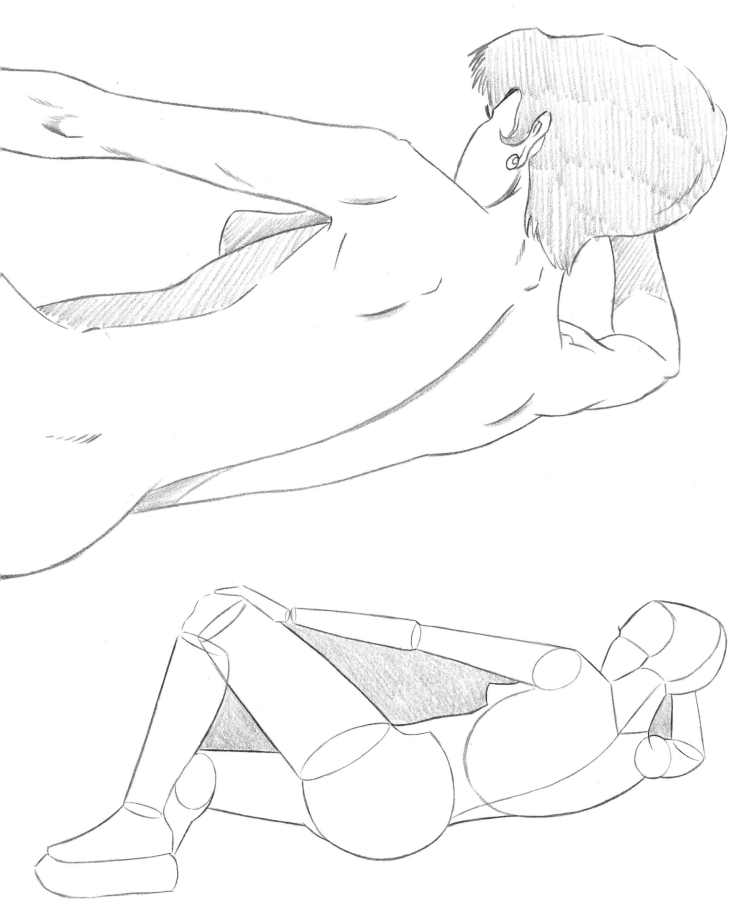

# WALKING

Notice how the shift in weight changes at places on the body.

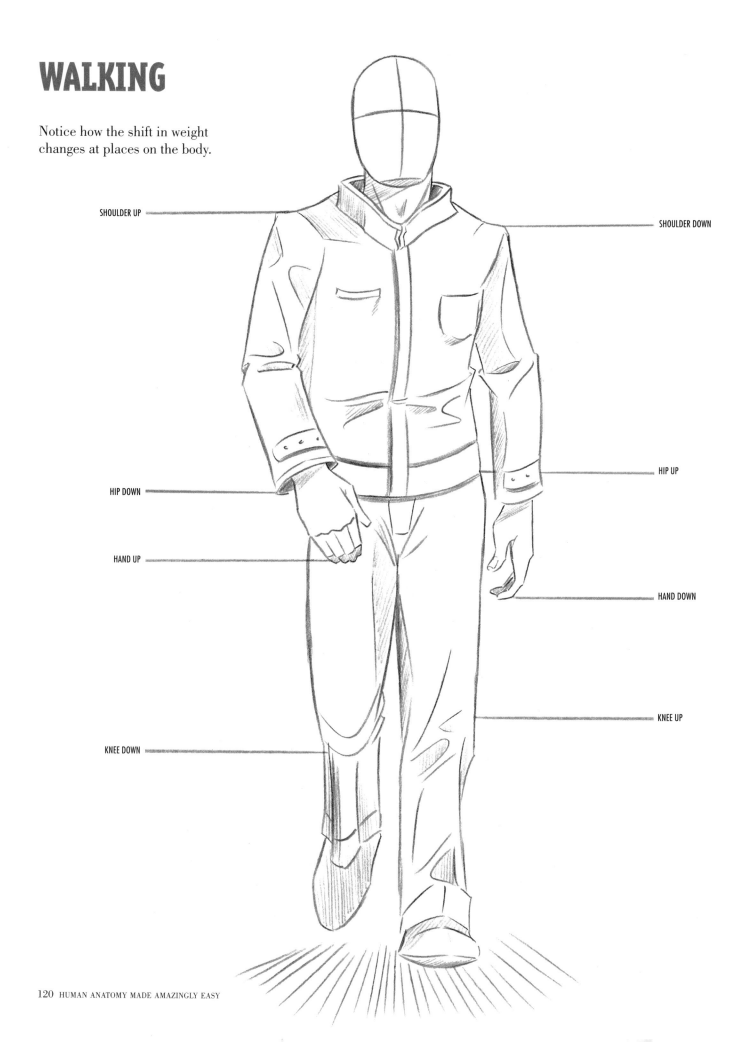

SHOULDER UP

SHOULDER DOWN

HIP UP

HIP DOWN

HAND UP

HAND DOWN

KNEE UP

KNEE DOWN

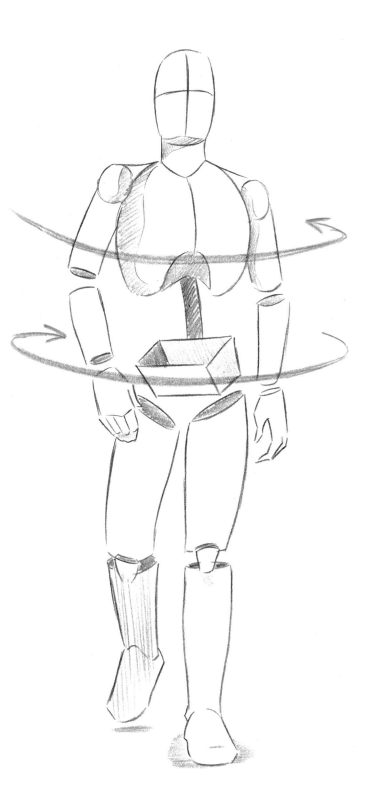
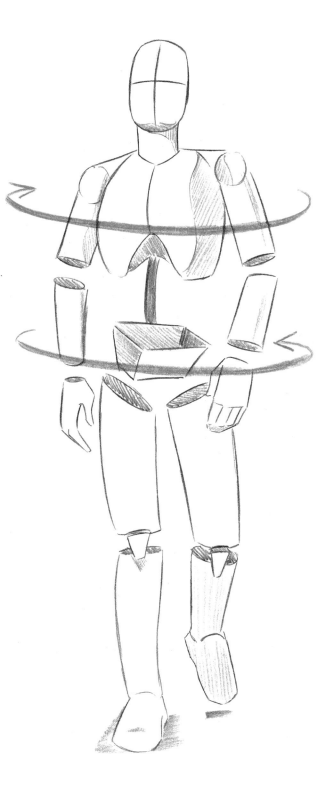

## HOW THE BODY TWISTS WHEN WALKING

As a person walks, the pelvis and leg move in an opposite direction to the rib cage and arm on the same side. The forward arm will always pull the rib cage forward. The backward arm will always pull the rib cage back. Likewise, the forward leg will always pull the pelvis forward. The backward leg will always pull the pelvis back.

# FLOWING POSES AND THE LINE OF ACTION

Up until now, we've been concentrating mainly on drawing various parts
of the body. That's all to the good, but I have always felt that anatomy books
in general are seriously deficient when they stop there. Drawing the figure
is more than the sum of all of its parts. You can illustrate a perfectly
proportioned man, yet it could still be stiff and lifeless. This problem is
solved by the correct use of the line of action.

   The line of action is an important guideline that the artist sketches in
lightly before he begins to draw a figure. You can also rough out your drawing
first, then sketch in the line of action afterward. This will help you to see if
the figure's pose is stiff or working against the natural flow of the body.
Then you can correct it before firming up the drawing.

   Note that the line of action doesn't have to travel in the same direction
as the arms and legs, although it often does. It is simply a line denoting the
general, overall flow of the pose. The line of action is most helpful when
drawing the figure from memory, rather than from a model. I've indicated the
line of action with a heavy line only for clarity's sake in these examples.

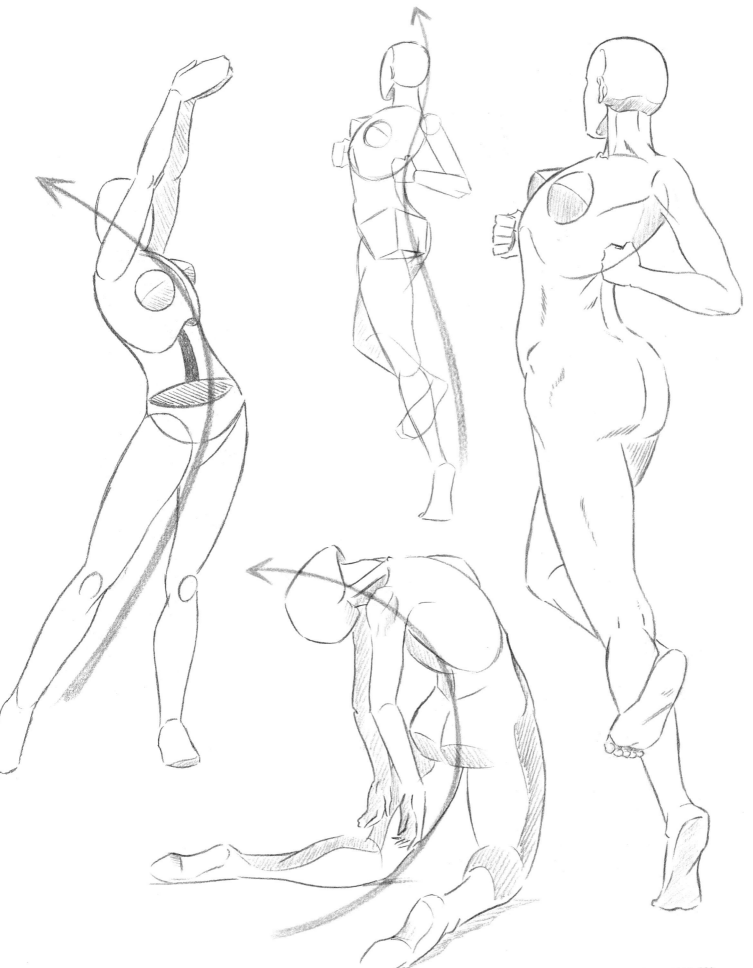

# FINDING MULTIPLE LINES OF ACTION

Finding the line of action within a figure is not a science. Although some poses will reveal obvious lines of action, others will not. It is up to the artist to decide where he or she feels the flow of the pose is going, and to choose where to put the line of action based on that feeling. Below is an example of the same poses repeated three different times with three different lines of action, any of which is correct.

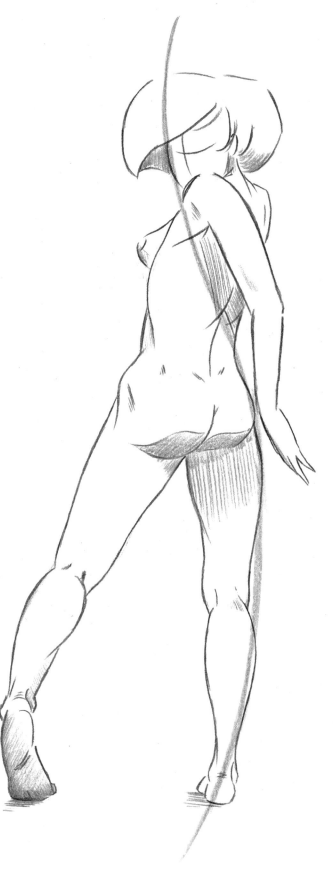

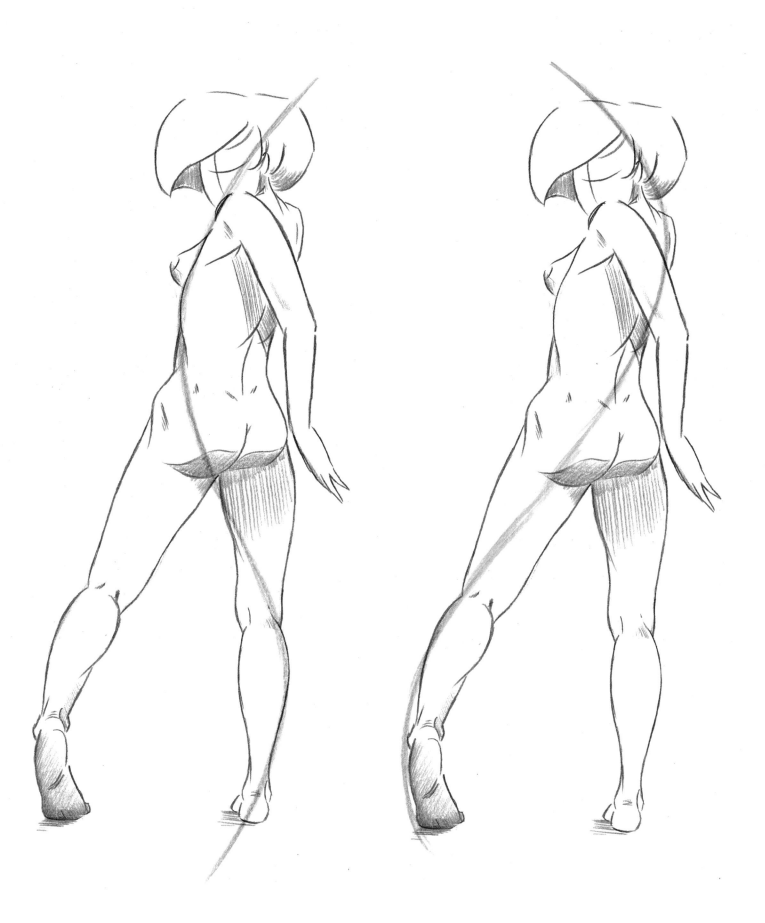

# USING TWO LINES OF ACTION IN THE SAME POSE

Poses where a lot is going on sometimes require two separate lines of action. Try to see flowing patterns within the pose.

The most obvious line of action is the diagonal line indicating the angle of the runner's momentum. By drawing the line of action through both arms, we can turn the arms into a single, graceful line, rather than two abrupt right angles.

The most obvious line of action is the one through the torso. By adding a line of action through the legs, we increase the flow of the drawing, making it more pleasing to the eye.

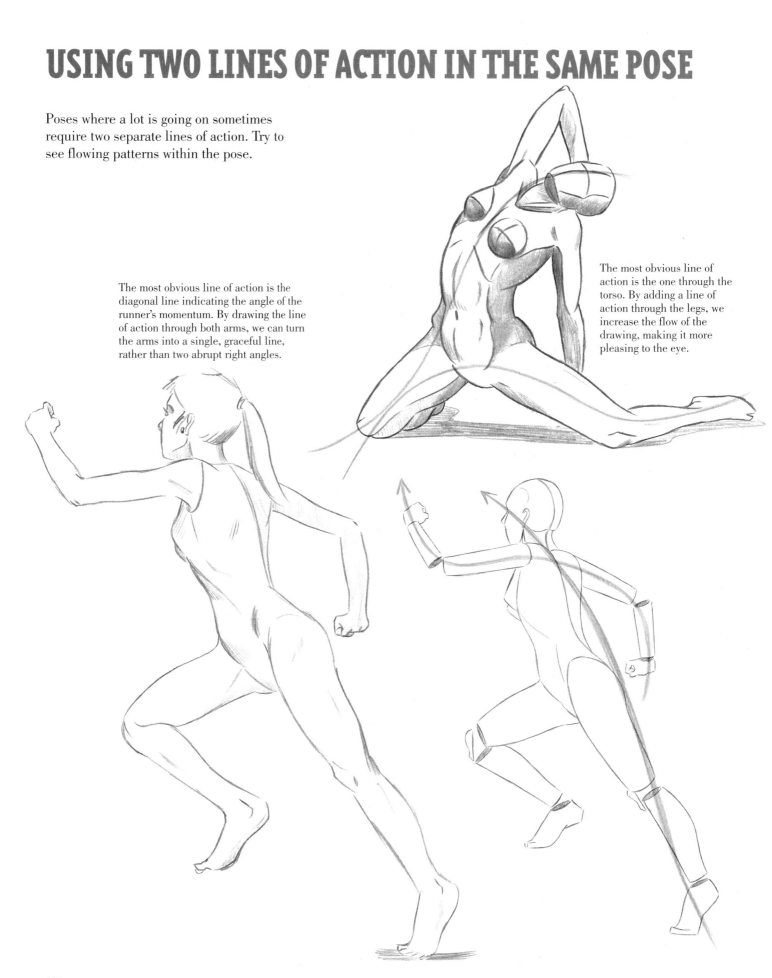

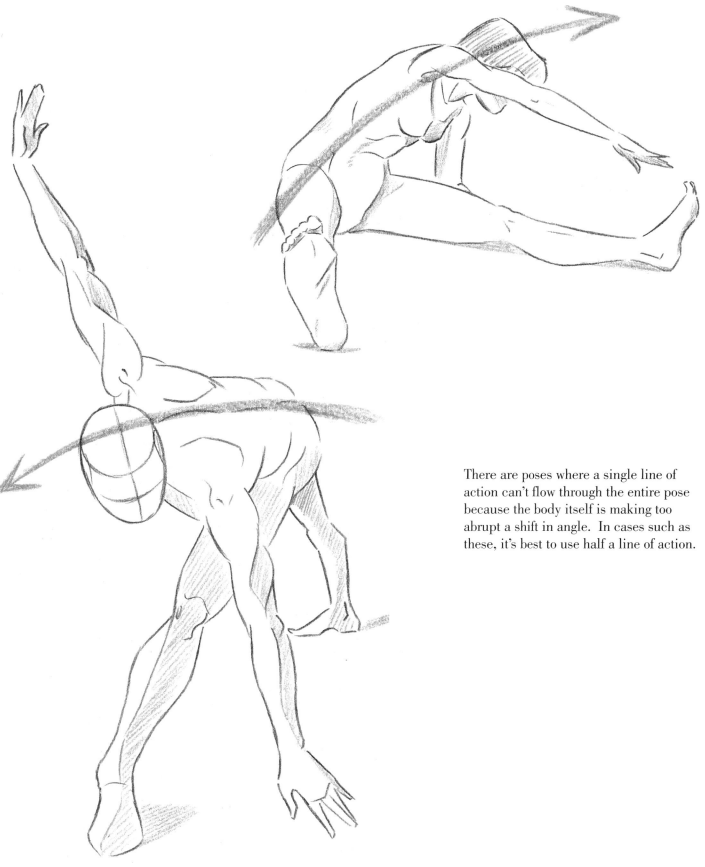

There are poses where a single line of action can't flow through the entire pose because the body itself is making too abrupt a shift in angle. In cases such as these, it's best to use half a line of action.

# THE POINT OF BALANCE

A line drawn from the pit of the neck directly to the ground indicates the point of balance. Posture, weight distribution, and motion are all involved in determining the point of balance.

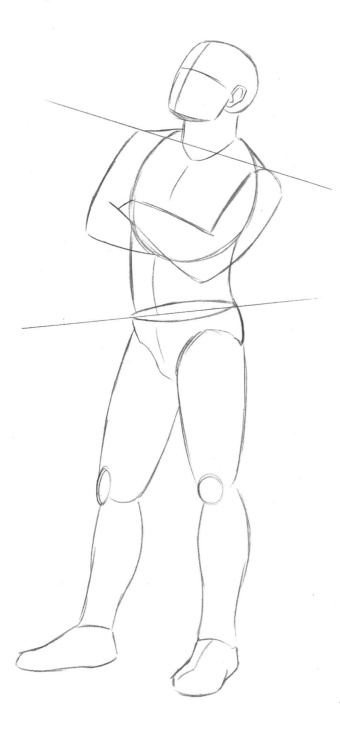

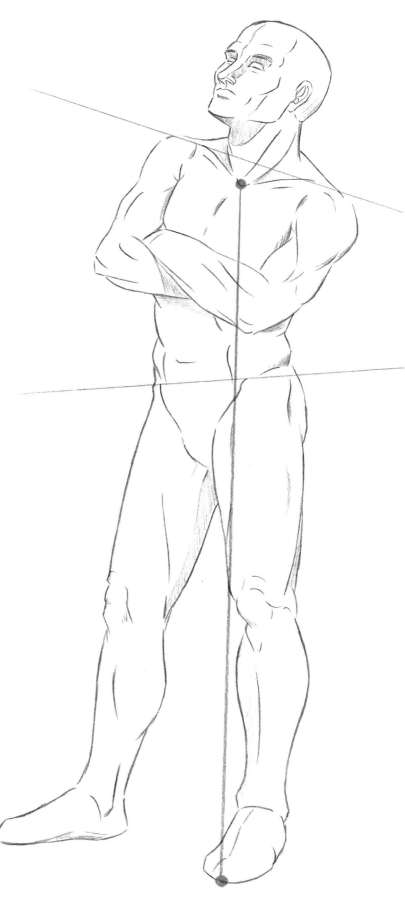

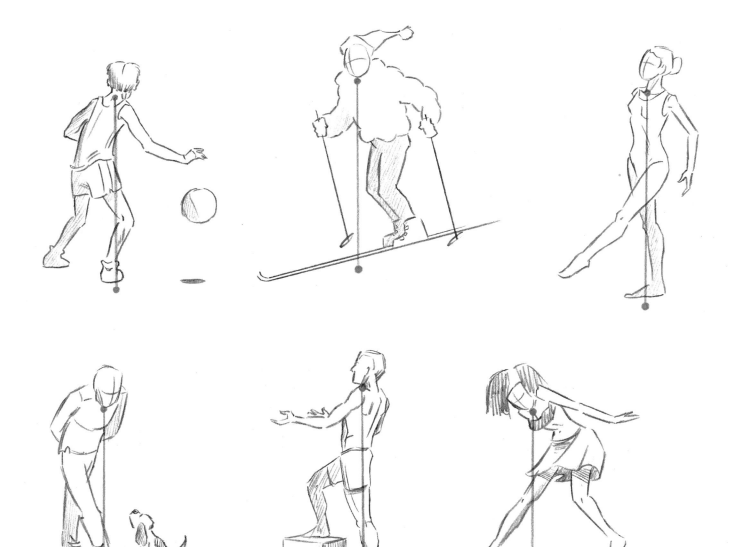

As you can see from the examples below, people tend to accommodate their point of balance by shifting positions. The rollerblader's point of balance is so far behind her that falling is her only recourse. When you think about shifting the weight in poses, remember to account for the point of balance.

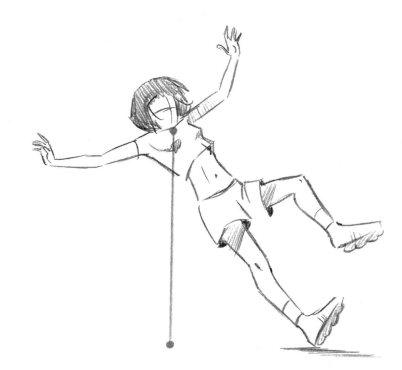

# PERSPECTIVE OF THE BODY

The body is affected by perspective, just as any other object. The body is narrow in width and long, not unlike a slim rectangular box. We can use two-point perspective to draw the body when it is at an angle to us.

Don't worry if two-point perspective is a new concept for you. The important thing to remember is that as the body diminishes in either direction, all the parts of the body will diminish along the same lines. For example, the two hands of the man in the drawing share the same vanishing lines. So do the knees, feet, pectoral muscles, eyes, elbows, and so on.

### LEVELS OF THE FEET
Perspective also requires us to adjust the levels of the feet, so that the far foot is higher than the near foot. Both feet could stand on the same level if he were not turned away, but rather stood squarely in front of us.

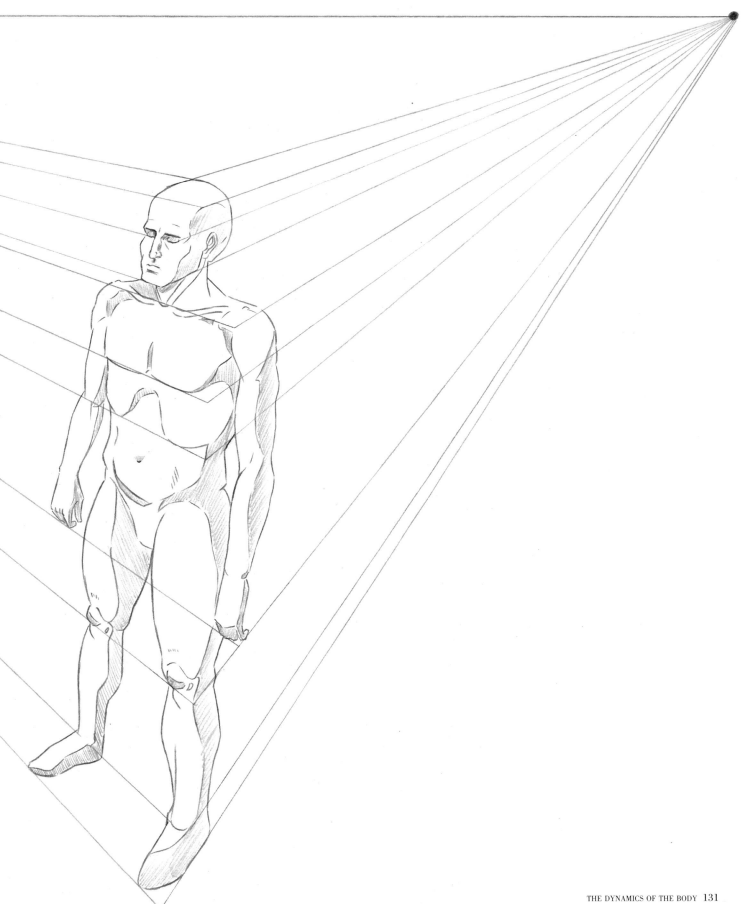

# THE EFFECTS OF PERSPECTIVE ON THE BODY

The horizon line represents the furthest visible distance. It is always at the viewer's eye level. Its placement is an arbitrary decision that you, the artist, decide according to your personal taste. In this example, I have placed the horizon line in the middle of the page.

The viewer always looks up at anything above the horizon line and down at everything below the horizon line. This principle applies when drawing the figure. Here we are looking up at the man's chin and his raised arm, and down at his legs and feet.

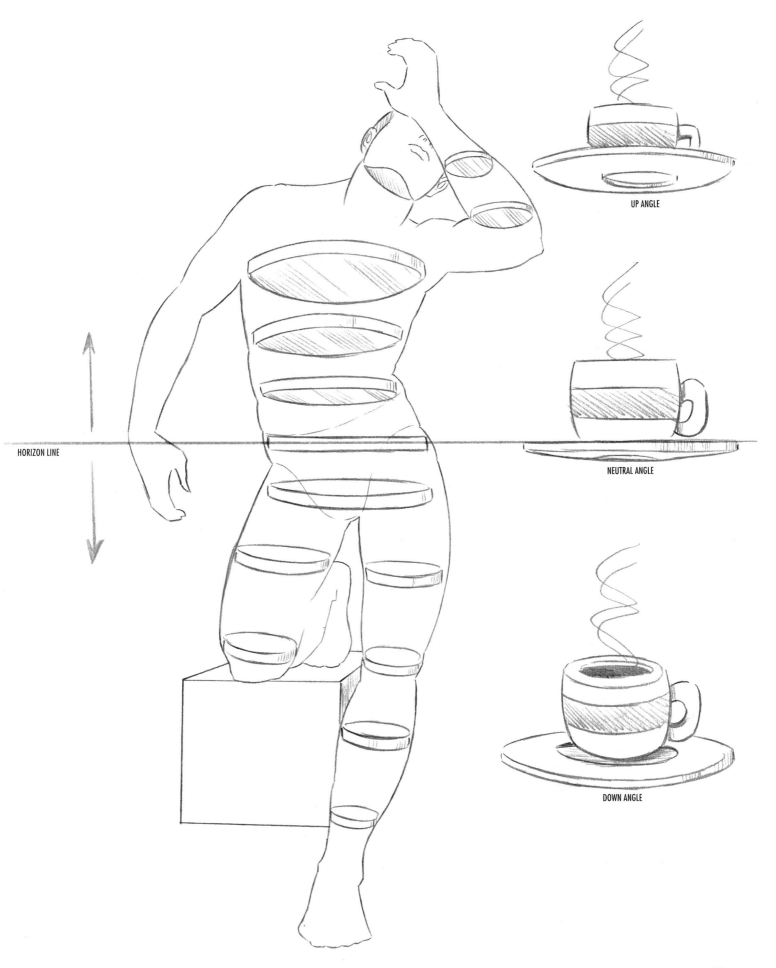

HORIZON LINE

UP ANGLE

NEUTRAL ANGLE

DOWN ANGLE

# PRACTICE POSES

Now that you have increased your familiarity with anatomy, try some of the following poses. Be aware of the anatomy, but don't be a slave to it. Express yourself. Change the position of an arm or a leg. See if that changes the balance of the body and adjust the pose to compensate for it. Turn the head in another direction to see if it adds drama.

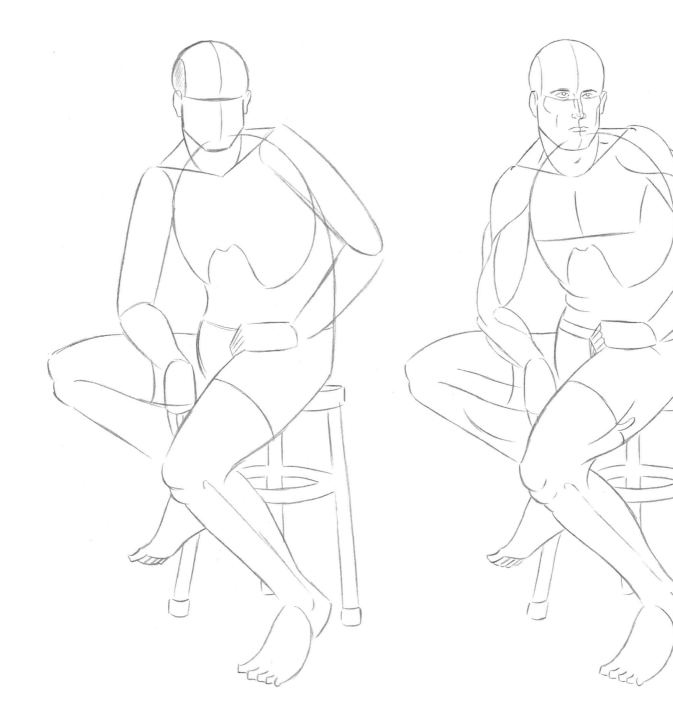

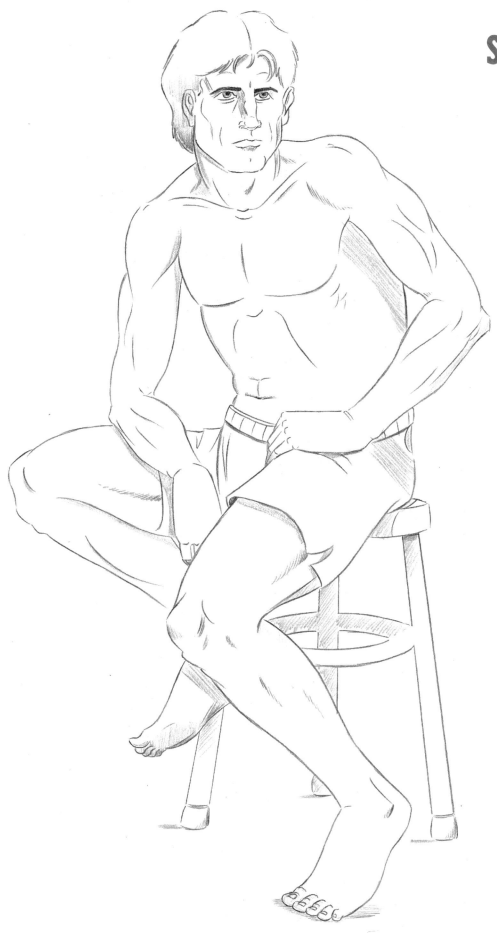

# STANDING POSE: Back View

At this point, you may prefer to skip the early construction stages and jump right to the final drawing. By all means, do so. But if you run into trouble, go back and reconstruct the part that is giving you difficulty, using basic shapes and muscle groups.

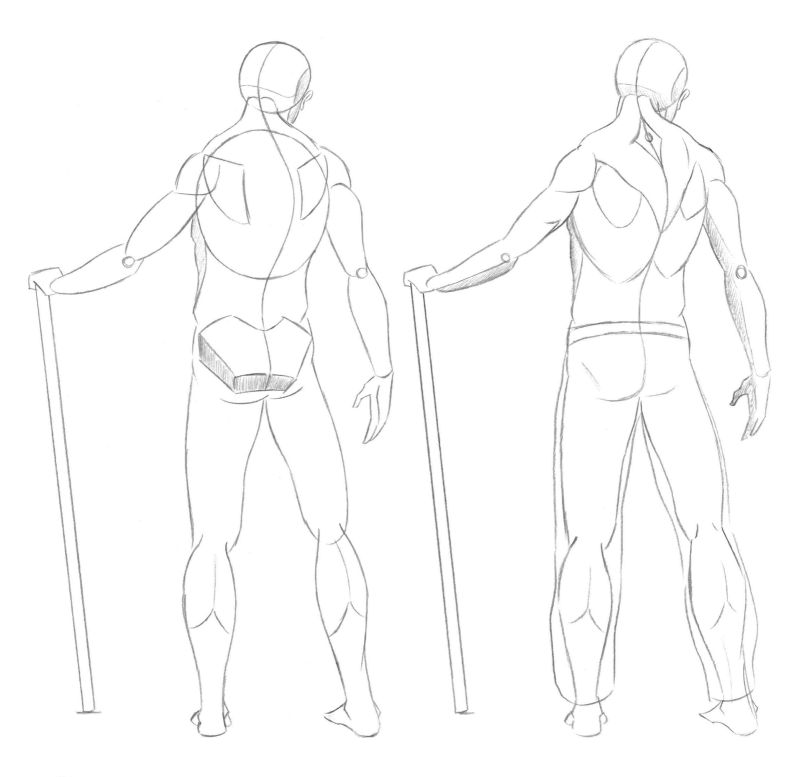

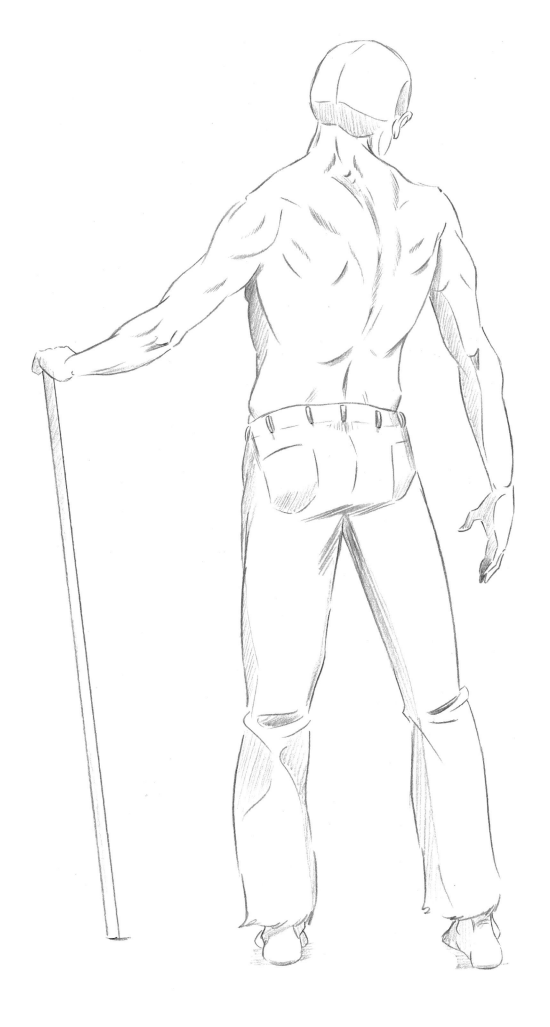

# RECLINING POSE: Front View

You can see how the various sections of the body move independently from each other, to some degree. It adds interest to a pose to twist and turn the body, rather than drawing it as a straight line.

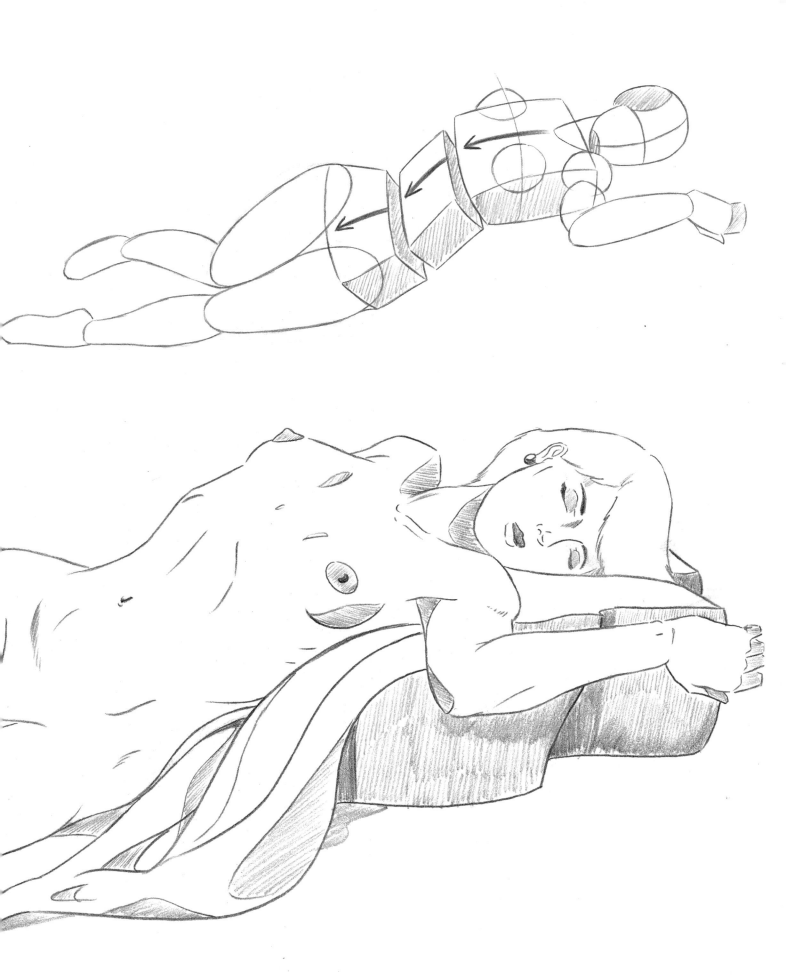

# RECLINING POSE: Side View

Reclining poses should express the feeling of weight, of the body relaxing, the muscles loose, limbs hanging. The breasts flatten, as does the stomach. All the tension is released by the body. The fingers and toes also relax.

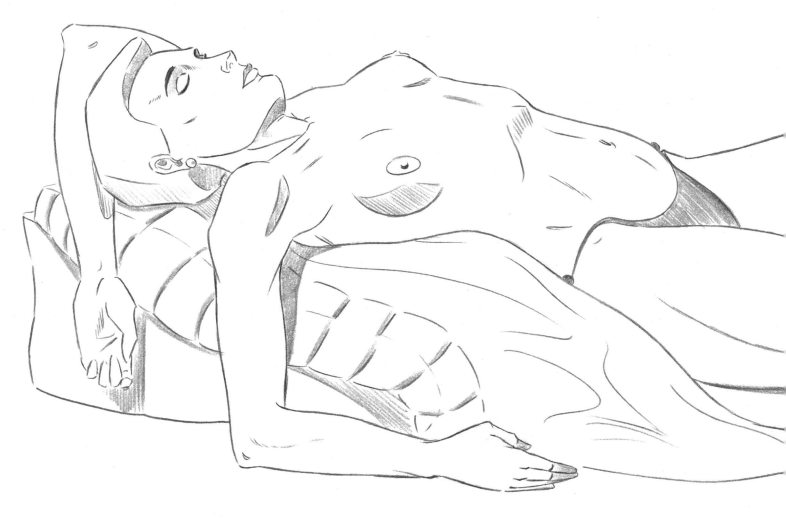

*Note the center line, which is used as a reference guide to denote the middle of the body.*

# RECLINING POSE: Back View

Reclining poses can be tricky. Not only is the body diminishing as it recedes from the viewer, but it also flattens out due to compression.

So we've come to the end of this book. I hope it's been helpful to you. Remember, not everybody has the muscular definition of the bodies in this book, but I've used athletic figures for clarity. Now that you have the information about the muscles, skeleton, and many other aspects of human anatomy, you can pick and choose what to emphasize. That is an artistic choice, which is always yours and yours alone.

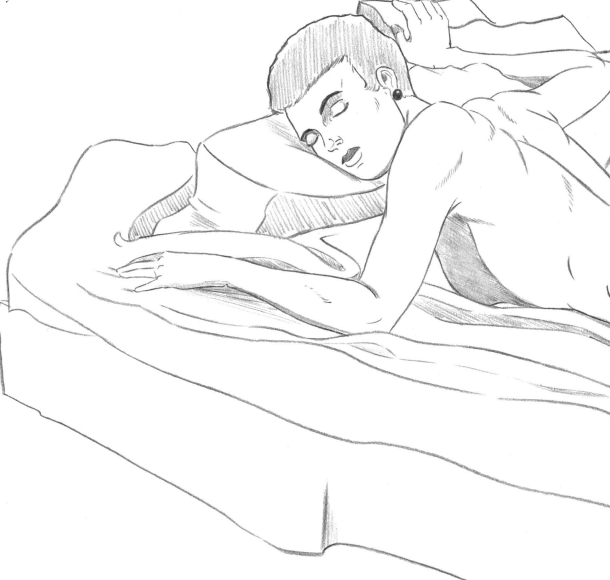

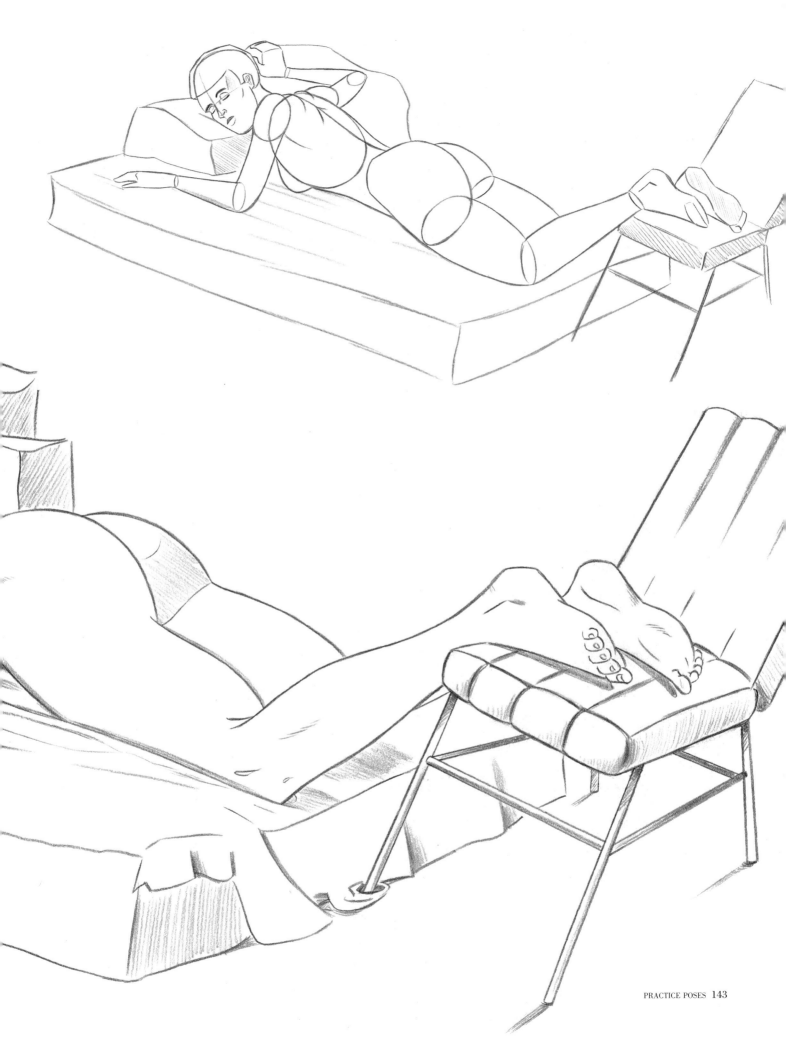

# INDEX

Action, lines of, 122–27
Ankles, 93, 99
Arms
    asymmetry of, 95–97
    bent, 84
    bones of, 66
    diminution of, 102–3
    forearm, 67, 97
    foreshortening, 104
    muscles of, 59, 64–68
    raised, 68, 78
    stretching and flexing, 100
Asymmetry, 25, 94–99

Back, 73–77
Back view, 49, 54–55, 59, 63, 83, 136–37, 142–43
Balance
    point of, 128–29
    and weight, 110–15
Body
    bones showing through, 52–55
    diminution of, 102–3, 108–9, 130
    feet, 92–93
    foreshortening, 104–7
    hands, 89–91
    hidden parts, 106–7
    measuring points, 116–17
    and negative space, 119–20
    pelvis, 51
    perspective of, 104–5, 130–33
    planes, 57
    point of balance, 128–29
    simplified, 56
    skeleton, 46–51
    weight and balance, 110–15
    See also Muscles; Poses

Calf muscles, 81, 82, 83, 84, 98
Caricatures, 45
Cheekbones, 9, 40
Chest, 78–80
Compression lines, 84–85

Diminution, 102–3, 108–9, 130

Ears, 10, 38–39
Eyebrows, 8, 28, 40
Eyes, 8, 9, 10, 16, 24–27, 40

Face
    angles of, 21, 22–23, 26–27, 31, 39, 42–43
    bones showing through, 13, 15
    caricatures, 45
    contour of, 11
    foreshortening, 23
    individuality of, 44

muscles of, 16
planes of, 17–19, 20
in profile, 10, 14, 15, 17
shadows of, 20
skull, 12, 14
spatial relationships, 8–9
See also specific features
Facial expressions, 36–37
Feet
    Angles of, 92–93
    levels of, 105, 130
Female/male comparisons
    eyebrows, 26
    forehead, 21
    hands, 90–91
    lips, 36
    nose, 32–33, 42
    pelvis, 51
    rib cage, 79–80
Figure. See Body; Poses
Fingernails, 91
Fingers, 89–91
Fist, 90
Forearm, 67, 97
Forehead, 21
Foreshortening, 23, 104–7

Hands, 89–91
Head. See Face
Hips, in weight-bearing pose, 111, 113
Horizon line, 132

Knee, 82, 86–87
    asymmetry, 98
    weight bearing, 114–15

Legs
    ankles, 93, 99
    calf, 81, 82, 83, 84, 98
    compression lines, 84–85
    foreshortening, 105
    knee, 82, 86–87, 98
    muscles of, 81–87
    stretching and flexing, 101
    weight bearing, 110–15
Lips, 9, 16, 34–37, 40

Mastoid process, 12
Measuring points, 116–17
Men. See Female/male comparisons
Model, drawing from, 116–19
Muscles
    arms, 64–68
    asymmetry of, 94–99
    back, 73–77
    chest and rib cage, 78–80

compression lines, 84–85
contour of, 60, 84
face, 9, 16
legs, 81–87
major, 58–59
neck, 62–63
shadows of, 61
shoulders, 59, 69–72

Neck, 62–63
Negative space, 118–19
Nose, 8, 14, 29–33

Perspective, 26–27, 104–5, 130–33
Planes
    of body, 57
    of face, 17–19, 20
Poses
    lines of action, 122–27
    reclining, 138–43
    seated, 134–35
    standing, 136–37
    walking, 120–21
Profile, 10, 14, 15, 17, 36
Pronation, 67
Proportions, 47–48

Rear view. See Back view
Reclining pose, 138–43
Rib cage, 79–80

Scapula, 70–72, 77
Seated pose, 134–35
Shadows
    of face, 20
    of muscles, 61
Shoulders, 59, 69–72, 77
Side view, 50, 82, 140–41
    See also Profile
Skeleton, 46–51
Skull, 12, 14
Smiles, 35, 36
Supination, 67

Tendons, 83
Thighs, 81, 82
Thin subjects, 80
3/4 view, 21, 22, 27
Thumb, 89
Toes, 93

Vanishing lines, 130

Walking, 120–21
Weight and balance, 110–15
Women. See Female/male comparisons